Chris Hart

Drawing
Vampires

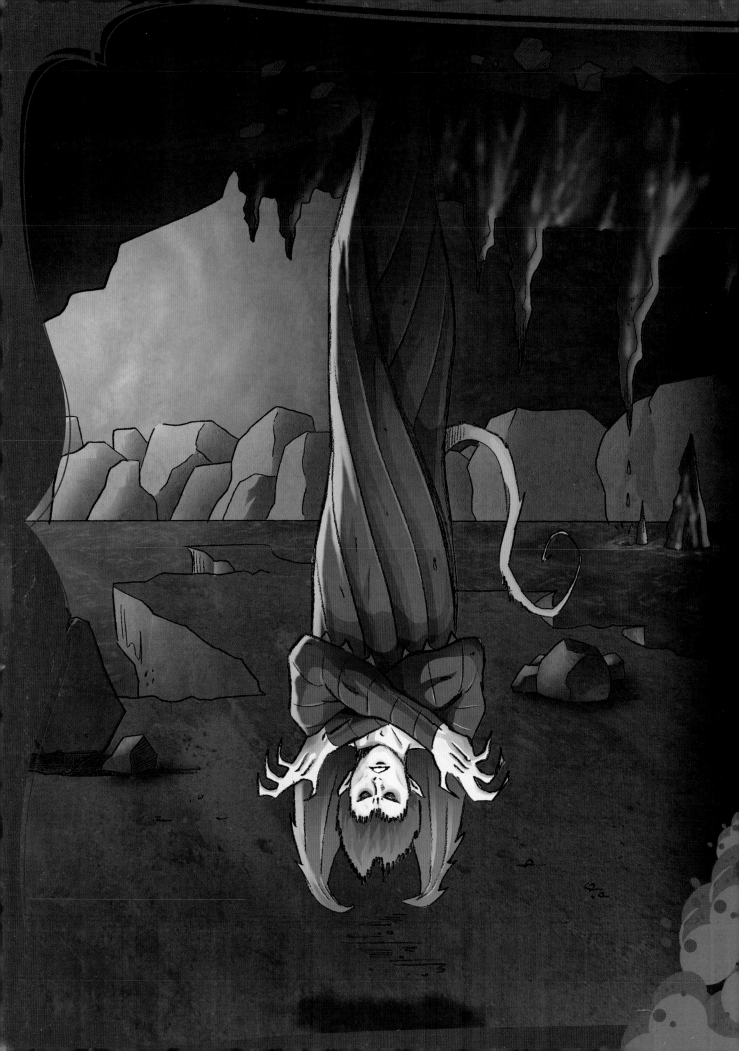

Drawing Vampires

Gothic Creatures of the Night

Chris Hart Books

Chris Hart Books

An imprint of Sixth&Spring Books
233 Spring St.
New York, NY 10013

Book Division Manager
WENDY WILLIAMS

Senior Editor
MICHELLE BREDESON

Art Director
DIANE LAMPHRON

Associate Art Director
SHEENA T. PAUL

Copy Editor
KRISTINA SIGLER

Color, Design and Additional Backgrounds
MADA DESIGN, INC.

Vice President, Publisher
TRISHA MALCOLM

Production Manager
DAVID JOINNIDES

Creative Director
JOE VIOR

President
ART JOINNIDES

Library of Congress Control Number: 2008936328

ISBN-13: 978-1-933027-81-4
ISBN-10: 1-933027-81-9

Manufactured in China

1 3 5 7 9 10 8 6 4 2

First Edition

Contents

www.CHRISHARTBOOKS.com

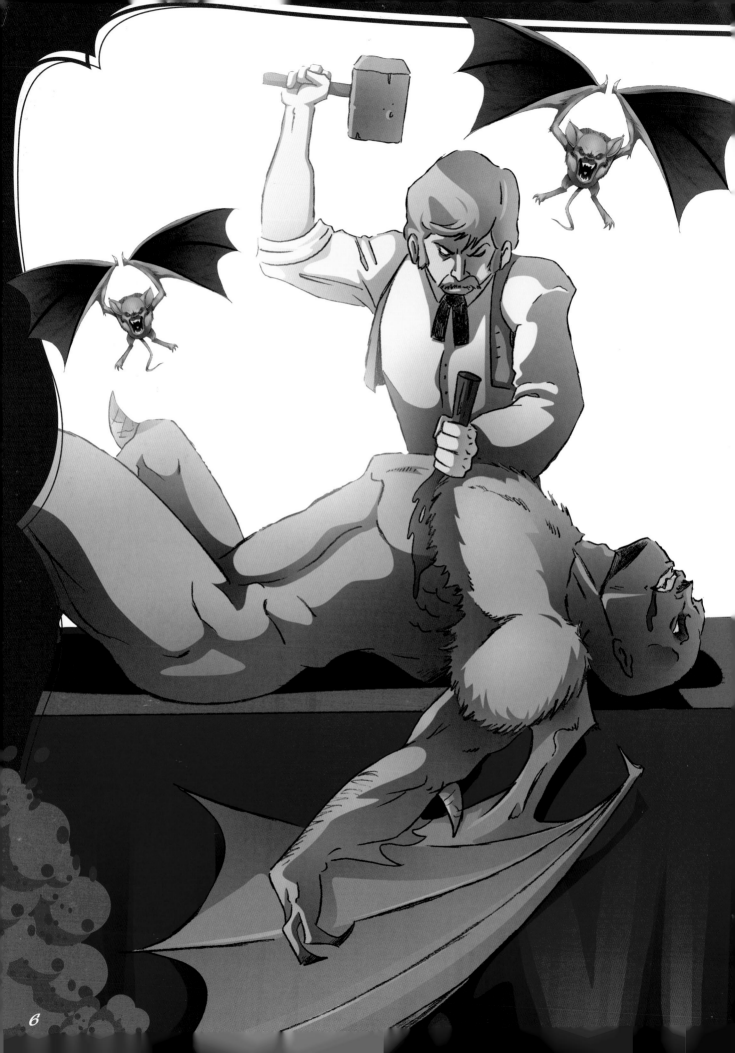

Introduction

Vampires: The very word evokes fear. Vampires have preyed on humans for centuries. Looking quite human themselves—some would even say handsome and charming—vampires can easily blend into society. But there is always that certain something, gothic and dark, that gives them away and makes them compelling to behold. *Drawing Vampires* will show you exactly how to create these haunting beings and other characters that inhabit their dark realm.

All of the most popular bloodsuckers are here in the flesh: classic Victorian vampires, terrifying otherworldly vampires, alluring lady vampires, modern vampires that appear to be cool twentysomethings but are in reality twohundredsomethings. To keep these fiendish ghouls from running amok, there is a chapter on drawing vampire hunters and their gruesome methods. Rounding out the book are the beasts of the vampire kingdom, creatures so terrible even vampires fear them.

You'll learn how to draw vampire heads, bodies and wings, as well as quintessential expressions and body language. Vampires in flight, the vampire's bite, action poses and classic cape poses are all covered in step-by-step demonstrations.

To draw vampires convincingly, it helps to be familiar with their habits and lore. "Legends of the Vampire," a special feature found throughout this book, will inspire you with more ideas from which to create, as well as valuable information on vampires' abilities and, more importantly, vulnerabilities. "Vampire Bites" are tasty morsels of trivia about vampires. Less experienced artists need not worry about biting off more than they can chew, because every drawing is broken down into easy-to-follow steps. The stakes are high, but with expert instruction, lots of visual hints and hundreds of step-by-step drawings, your efforts won't be "in vein."

So pick up a pencil, grab a piece of paper, and let's get started. Oh, and make sure you have a string of garlic nearby—you're going to need it.

CLASSIC VAMPIRES
Drawing the Head

When people think of vampires, the first image that usually comes to mind is a handsome, mysterious, even dashing figure. The classic vampire can usually pass for a human, at least until he bares his fangs. Other clues to his true identity can include piercing, devilish eyes and slightly pointed ears. In this chapter, we'll learn to draw the facial features and expressions of these charismatic creatures of the night and explore options for varying their looks.

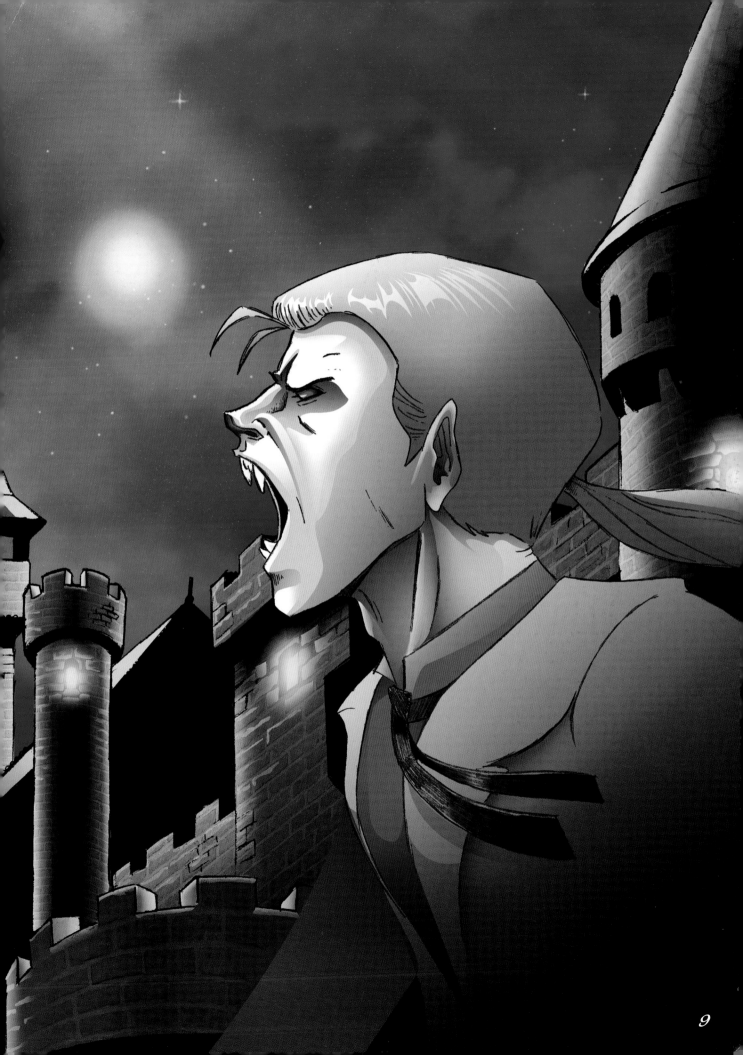

Aristocratic Vampire

Vampire tales are commonly set in the Victorian era. In these stories, the undead are often cast as wealthy scions of royalty, secluded in their castles, at which they host their deadly soirees. The guests may enjoy the early part of the evening, but the latter part of the night is a killer.

The aristocratic vampire has style. In this front view, we begin with delicate features and piercing eyes. The goatee is vaguely devilish, which is why it works so well.

You don't have to show the vampire's fangs at all times. If he always goes around baring his fangs, no one will ever accept his invitations!

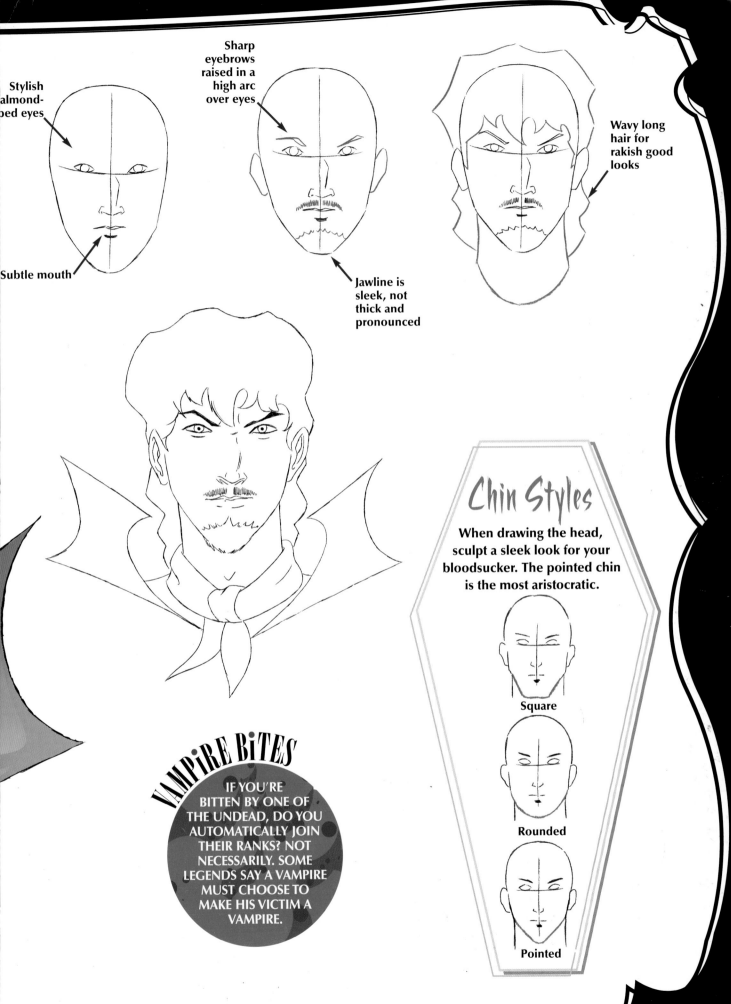

Stylish almond-shaped eyes

Subtle mouth

Sharp eyebrows raised in a high arc over eyes

Jawline is sleek, not thick and pronounced

Wavy long hair for rakish good looks

Chin Styles

When drawing the head, sculpt a sleek look for your bloodsucker. The pointed chin is the most aristocratic.

Square

Rounded

Pointed

VAMPIRE BITES

IF YOU'RE BITTEN BY ONE OF THE UNDEAD, DO YOU AUTOMATICALLY JOIN THEIR RANKS? NOT NECESSARILY. SOME LEGENDS SAY A VAMPIRE MUST CHOOSE TO MAKE HIS VICTIM A VAMPIRE.

Ready to Bite!

The bite is always portrayed as a big moment. It's never a little nip on the neck. This is one of the defining actions of a vampire. After all, the consequences of being bitten are pretty serious. You become undead, for example.

Drawing the attacking vampire in the side view can be tricky, so here are a few hints.

Nose Position

When the vampire gets ready to bite, he opens his mouth wide, causing the nose to turn up in response.

Wrong!
Nose down makes no adjustment for bite.

Right!
Nose pulled up to make room for bite.

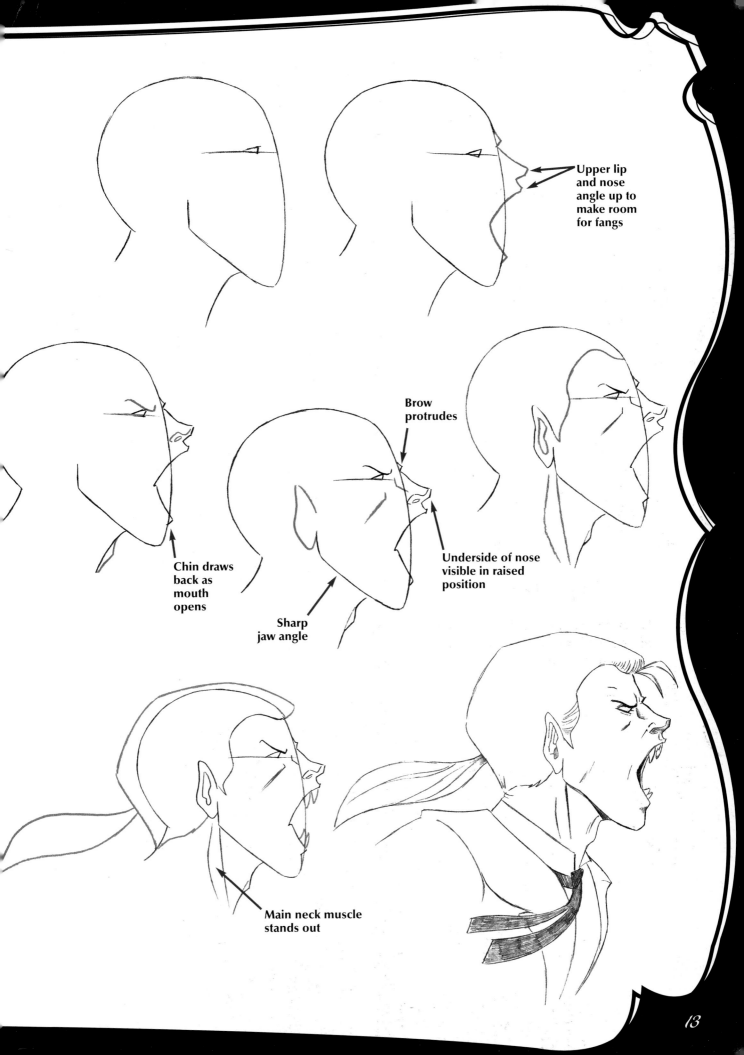

Upper lip
and nose
angle up to
make room
for fangs

Brow
protrudes

Chin draws
back as
mouth
opens

Sharp
jaw angle

Underside of nose
visible in raised
position

Main neck muscle
stands out

The Count

Mysterious, but also elegantly evil, the master of the castle is an imposing figure. He's a perfectly charming host...until it's time for the main course.

Checklist for Evil Eyes

A dark, knowing look is always a good expression for vampire characters. Even a vampire hoping to pass for human cannot conceal the terrible hunger in his eyes. The eyes must seem urgent, depraved, wicked. Only a few simple flourishes are required to accomplish this.

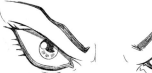 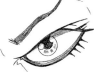

- ❑ **Sharply drawn, thin eyebrows angle down severely**
- ❑ **Eyes tilt up at ends**
- ❑ **Small irises and pupils**
- ❑ **Heavy line for the lower eyelid**
- ❑ **Lower eyelashes drawn in, and emphasized, even on males**
- ❑ **Upper eyelids crush down on eyes, giving them a grave look**

Origins of Dracula

Bram Stoker's *Dracula* was partly inspired by Vlad the Impaler, a fifteenth-century Romanian prince whose father was named Dracul. Vlad enjoyed the taste of cruelty and killed his enemies in ruthless and horrible ways, including, of course, impalement. Some legends say that after his death strange killings began to occur in the countryside, with eyewitness accounts putting Vlad the Impaler at the scene of the murders. Two holes in the side of the neck of each victim marked the method of the crimes. It was believed that Vlad the Impaler had traversed the bridge from death to life, to return, undead, and continue his reign of terror—on all humans!

Fangs Bared!

You're one of the lucky ones. Most people who see a vampire in this pose don't live to see much else. The mouth stretches, and the eyes open wide. Note the big crunch of wrinkles at the bridge of the nose — they occur naturally as the upper lip draws back to reveal fangs.

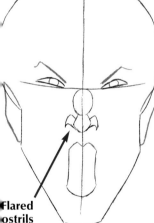

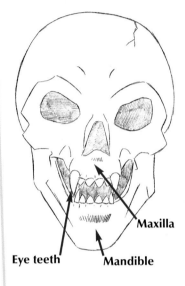

Take a Bite Out of This

To draw vampires in attack mode, it helps to take a look at the skull and the interior of the mouth.

Fangs

The teeth are wedged deeply into the skull, at the maxilla (upper jaw) and mandible (lower jaw). The vampire's "eye teeth," which are also called cuspids or canine teeth, are always drawn as fangs. But the rest of the front teeth can also become sharp when the beast is ready to bite. If a vampire is trying to pass as human, he can hide his fangs, and all of his teeth will appear normal. Some say that vampires can retract their fangs like a cat can its claws.

Mouth stretches vertically

Flared nostrils

Maxilla

Eye teeth

Mandible

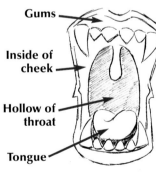

Gums

Inside of cheek

Hollow of throat

Tongue

Mouth Details

Rather than simply shading the interior of the mouth, try working in some details. Here are four elements that are essential to any good bite pose that shows the interior of the mouth. An exception is when the character is drawn very small. Then you may not have room to show all of the details.

"Say aaahhh!"

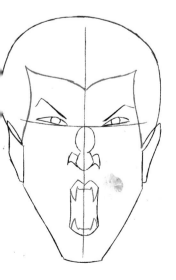

Eerie Vampire

Drawing a character as if he is looking down at you creates an eerie impression and makes the reader feel vulnerable. This low-angle shot is particularly apt for a vampire, who is always on the hunt for his next victim. Draw the features carefully along the curved guidelines to make this angle work. It's important to draw the eyes partially cut off by the lower eyelids.

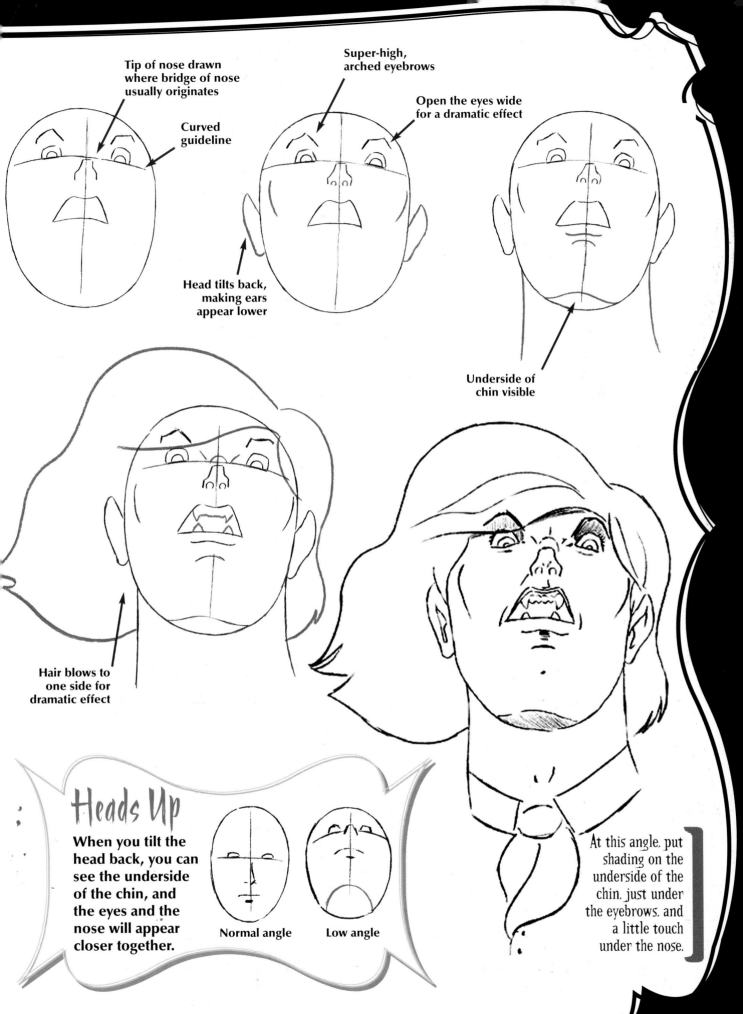

Tip of nose drawn where bridge of nose usually originates

Super-high, arched eyebrows

Curved guideline

Open the eyes wide for a dramatic effect

Head tilts back, making ears appear lower

Underside of chin visible

Hair blows to one side for dramatic effect

Heads Up

When you tilt the head back, you can see the underside of the chin, and the eyes and the nose will appear closer together.

Normal angle

Low angle

At this angle, put shading on the underside of the chin, just under the eyebrows, and a little touch under the nose.

19

Head Angles

Drawing heads at different angles encourages you to visualize your characters in a three-dimensional manner. You don't want to limit yourself to drawing only front views. Keep the faces basic and nondescript so you can focus on getting the form right. While sketching, you don't even need to reproduce all the detail you see in these examples. A basic mannequin head is all that's required to practice different angles, although I've added a little flair to the eyes, ears and teeth to bring out the vampire in them.

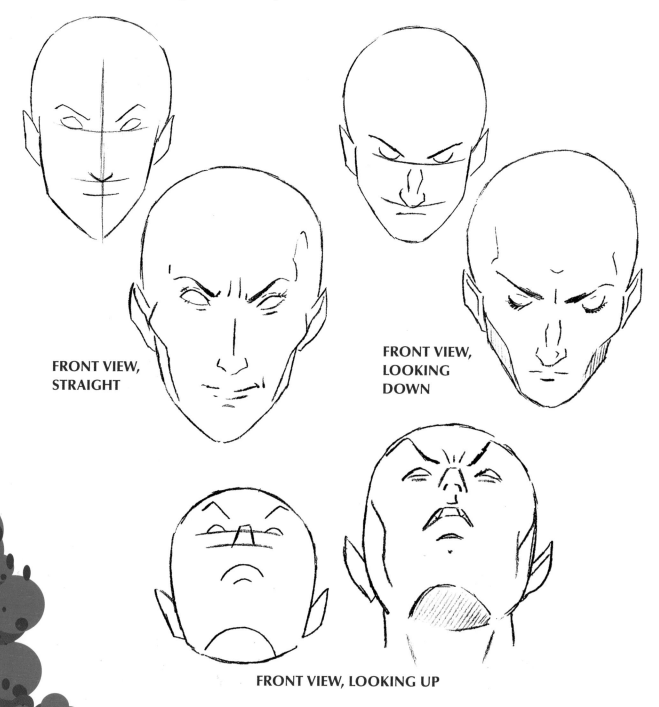

FRONT VIEW, STRAIGHT

FRONT VIEW, LOOKING DOWN

FRONT VIEW, LOOKING UP

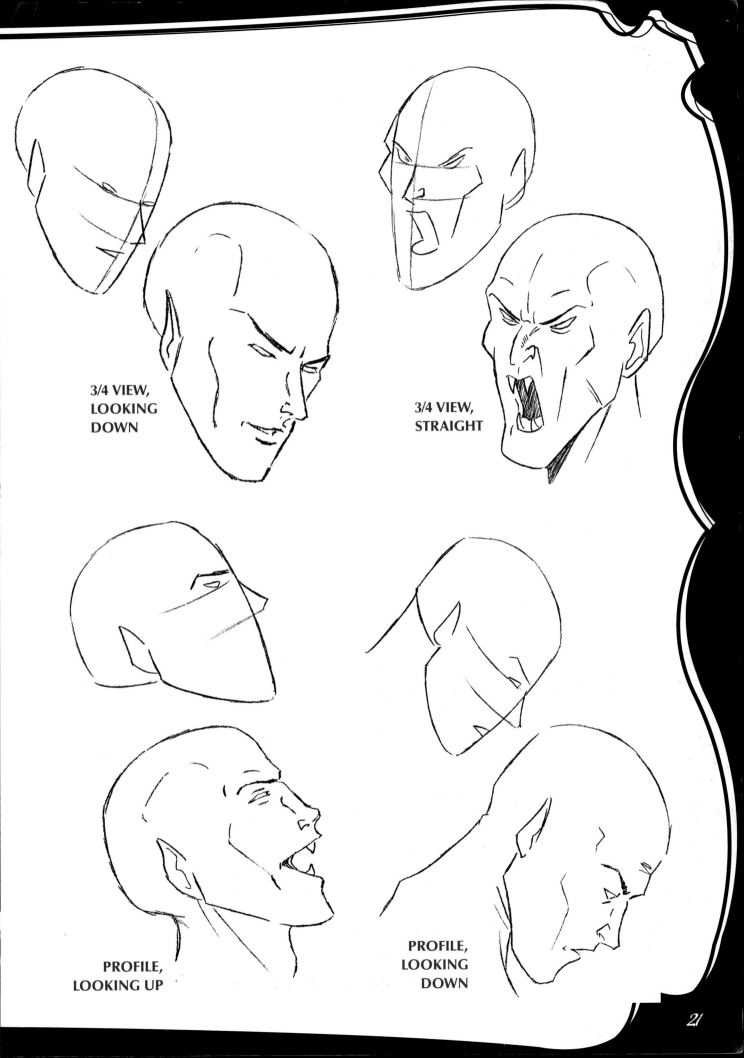

3/4 VIEW, LOOKING DOWN

3/4 VIEW, STRAIGHT

PROFILE, LOOKING UP

PROFILE, LOOKING DOWN

21

A Vampire in London

Many movies and TV shows have depicted vampires along the lines of supernatural Jack the Rippers attired in Victorian London suits and top hats. But when the top hat tilts back, the poisonous being revealed is at odds with his sartorial splendor. His expression almost transforms him into an animal with empty, soulless eyes.

Small eyes read as evil

Cheekbones become pronounced…

…and nose crinkles when mouth opens wide

Enlarge the ears for a wilder look

Long, narrow mouth

Brim of hat overlaps head

Top hat is same length as the head

Sharpen the strands of hair around his face

Leaving eyes blank gives him the look of a killer

The Rough Sketch

Here's my initial sketch before I traced over it to create the final version. Note the long, bold lines, some of which I've redrawn several times.

The hair doesn't have to be untamed and wild all the time. But when the expression becomes extreme, whipping the hair about underscores the mood.

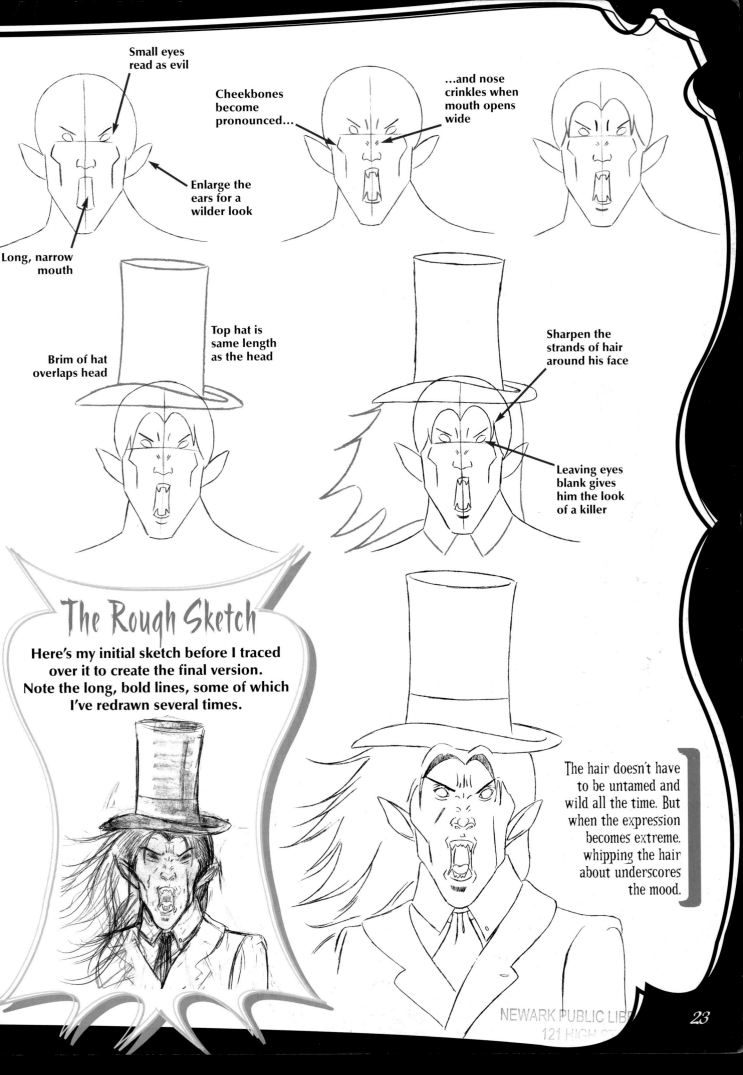

Vampire Nobility

There are many techniques you can use to show your vampire's high rank in the vampire pecking order.

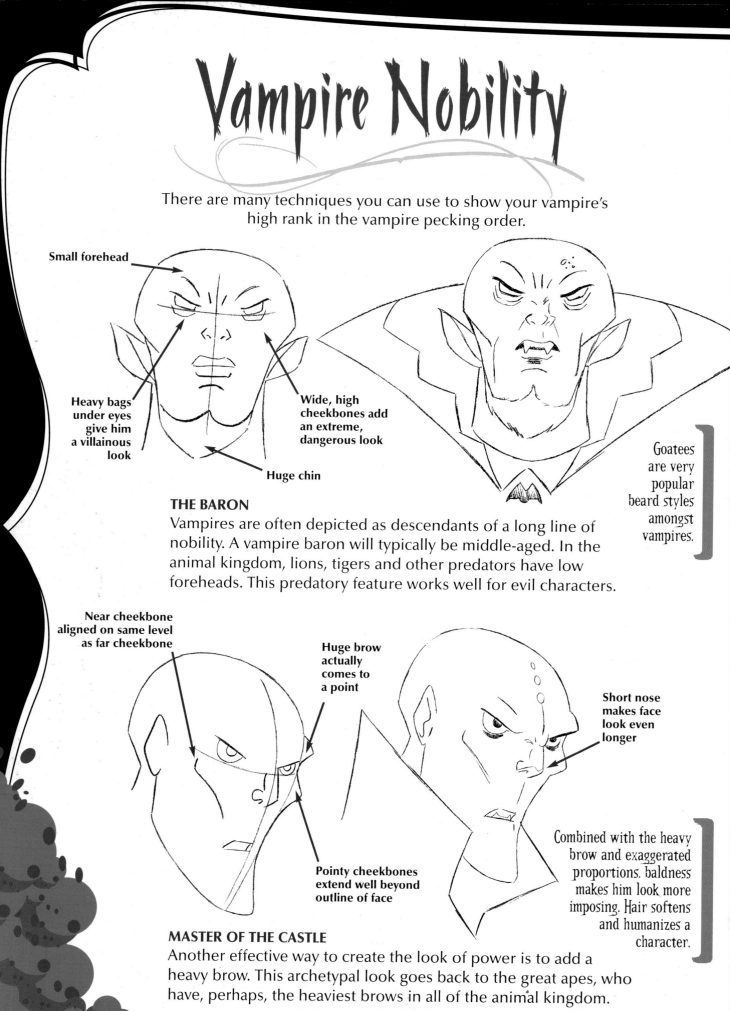

Small forehead

Heavy bags under eyes give him a villainous look

Wide, high cheekbones add an extreme, dangerous look

Huge chin

THE BARON
Vampires are often depicted as descendants of a long line of nobility. A vampire baron will typically be middle-aged. In the animal kingdom, lions, tigers and other predators have low foreheads. This predatory feature works well for evil characters.

Goatees are very popular beard styles amongst vampires.

Near cheekbone aligned on same level as far cheekbone

Huge brow actually comes to a point

Short nose makes face look even longer

Pointy cheekbones extend well beyond outline of face

Combined with the heavy brow and exaggerated proportions, baldness makes him look more imposing. Hair softens and humanizes a character.

MASTER OF THE CASTLE
Another effective way to create the look of power is to add a heavy brow. This archetypal look goes back to the great apes, who have, perhaps, the heaviest brows in all of the animal kingdom.

Transformations

Vampirism is a sickness that often takes victims unawares (although the bite marks on the neck should have been a warning sign). As the disease begins to manifest itself, the victim is confused and doesn't know what is happening to him, but is aware, nonetheless, that he is changing into something terrible. Once it begins, nothing can stop the transformation.

Dearest Emily,
I have secluded myself in my estate, apart from everyone. I feel that something awful is happening to me. I am turning into something that I cannot comprehend and cannot stop. Oh Emily, stay away!

CLASSIC VAMPIRES
Full-Body Poses

Now that we've drawn a variety of heads and character types, we're going to add the rest of the body to create complete characters. In the process, we'll cover the subjects of wardrobe and body language. This chapter may even inspire you to create your own vampire characters, which are probably lurking somewhere in the darkness of your soul!

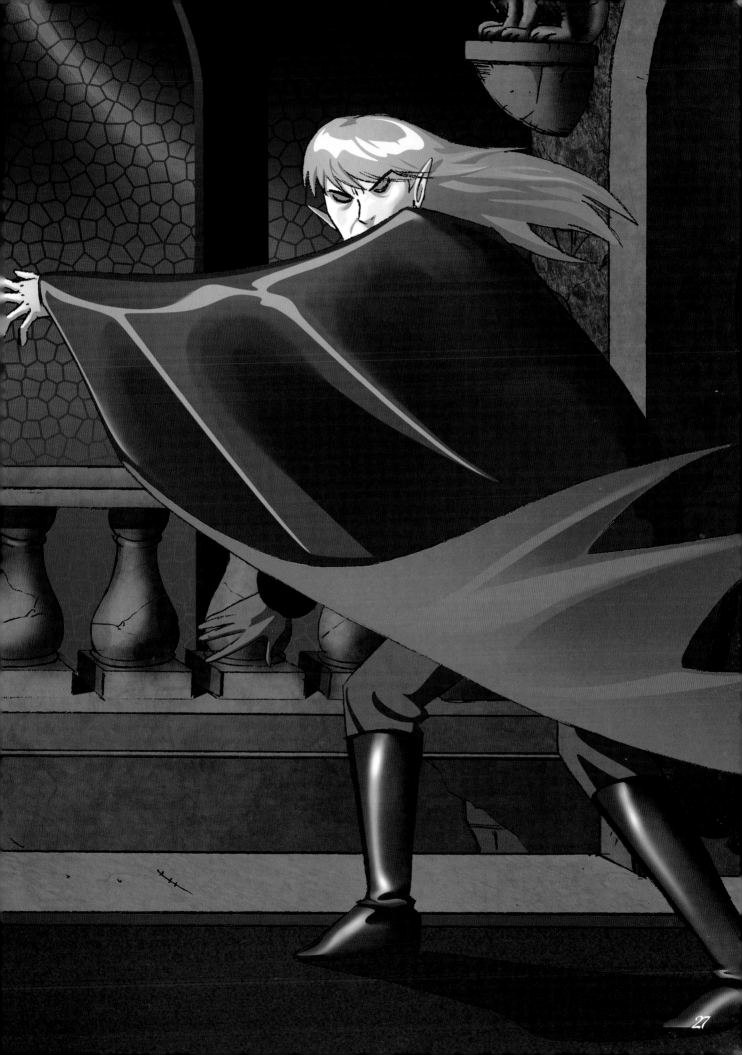

Charming Vampire

This debonair host is the quintessential vampire who has appeared in countless comics and films—and still does. He is charismatic and engaging, with just a glint of evil in his eye. Not a physically powerful figure per se, he is nonetheless commanding in appearance.

Vampire Abilities

As if living for centuries and drinking blood didn't make them frightening enough, here are a few skills vampires are known to possess:

- Flight/levitation
- Walking up walls
- Super speed
- Superhuman strength
- Mind control
- Reading minds
- Telekinetics (moving objects with their mind)
- Pyrokinetics (starting fires with their mind)
- Shape shifting (can turn into bats or sometimes wolves)
- Superhuman hearing, smell and sight

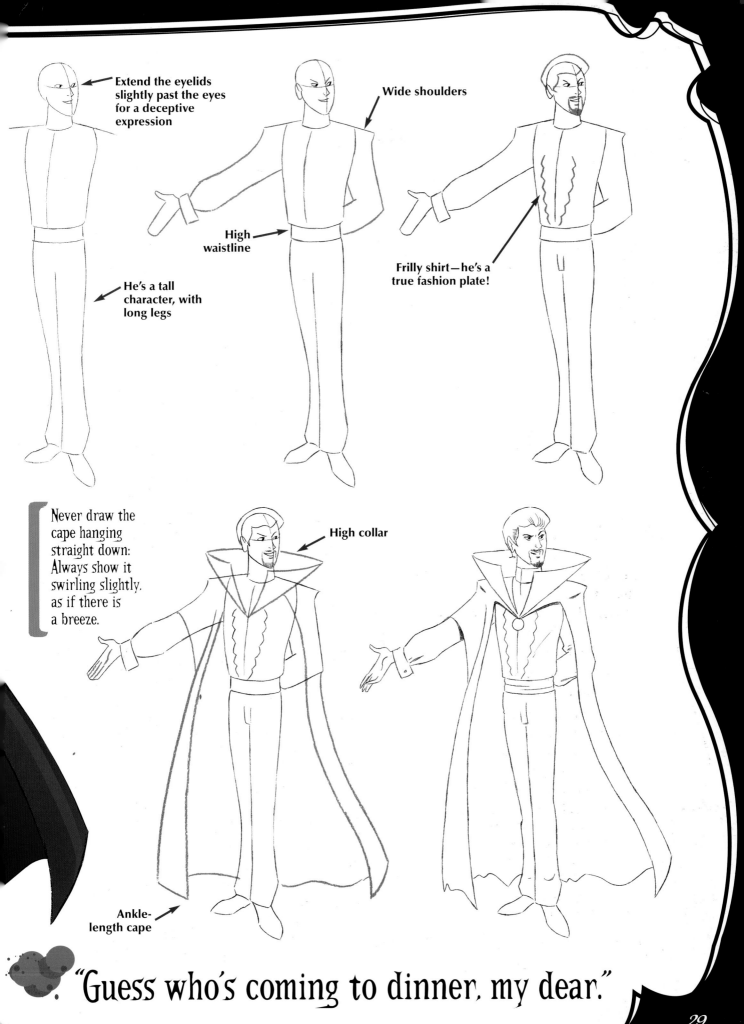

Extend the eyelids slightly past the eyes for a deceptive expression

Wide shoulders

High waistline

Frilly shirt—he's a true fashion plate!

He's a tall character, with long legs

Never draw the cape hanging straight down: Always show it swirling slightly. as if there is a breeze.

High collar

Ankle-length cape

"Guess who's coming to dinner, my dear."

Horror-Style Vampire

A vampire can change quickly from charming to wrathful, revealing his true nature. The eyes become empty, the fangs grow suddenly into place, the ears elongate and facial stubble even appears. He becomes something hideous and only partially human. This is a popular treatment in contemporary vampire stories.

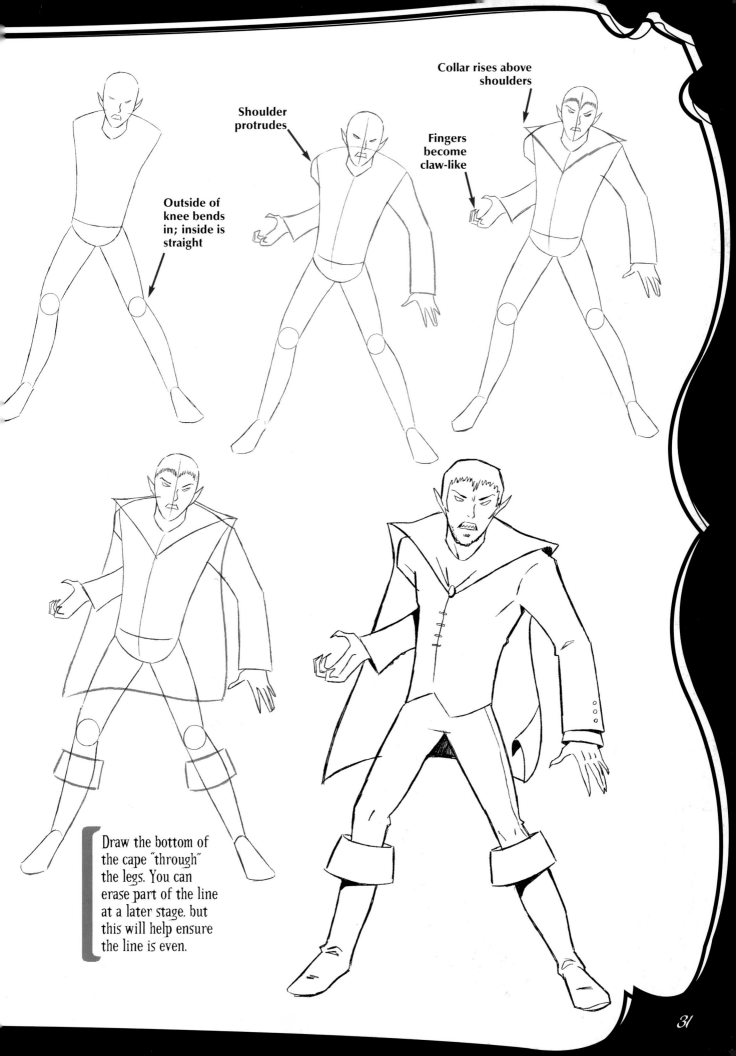

Collar rises above shoulders

Shoulder protrudes

Fingers become claw-like

Outside of knee bends in; inside is straight

Draw the bottom of the cape "through" the legs. You can erase part of the line at a later stage, but this will help ensure the line is even.

Modern Victorian

Mixing genres is a popular technique used in contemporary graphic novels. This mysterious fellow has the cape, sash and high boots of an earlier era, but his face is hip and young. Putting modern-looking characters in period clothing is a good way to combine genres.

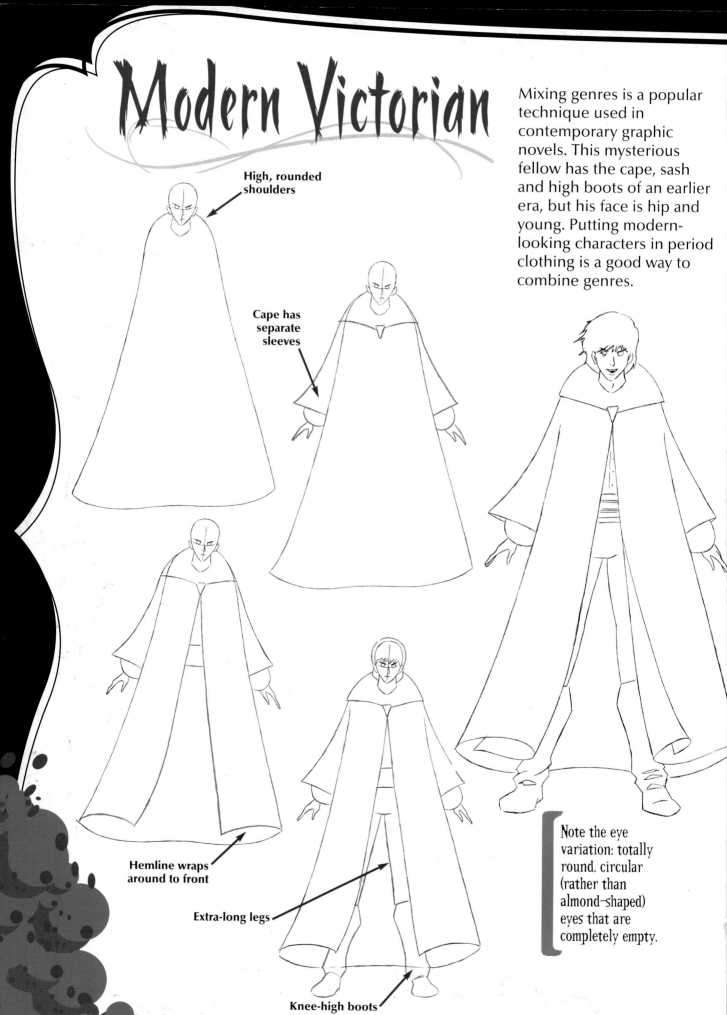

High, rounded shoulders

Cape has separate sleeves

Hemline wraps around to front

Extra-long legs

Knee-high boots

Note the eye variation: totally round, circular (rather than almond-shaped) eyes that are completely empty.

32

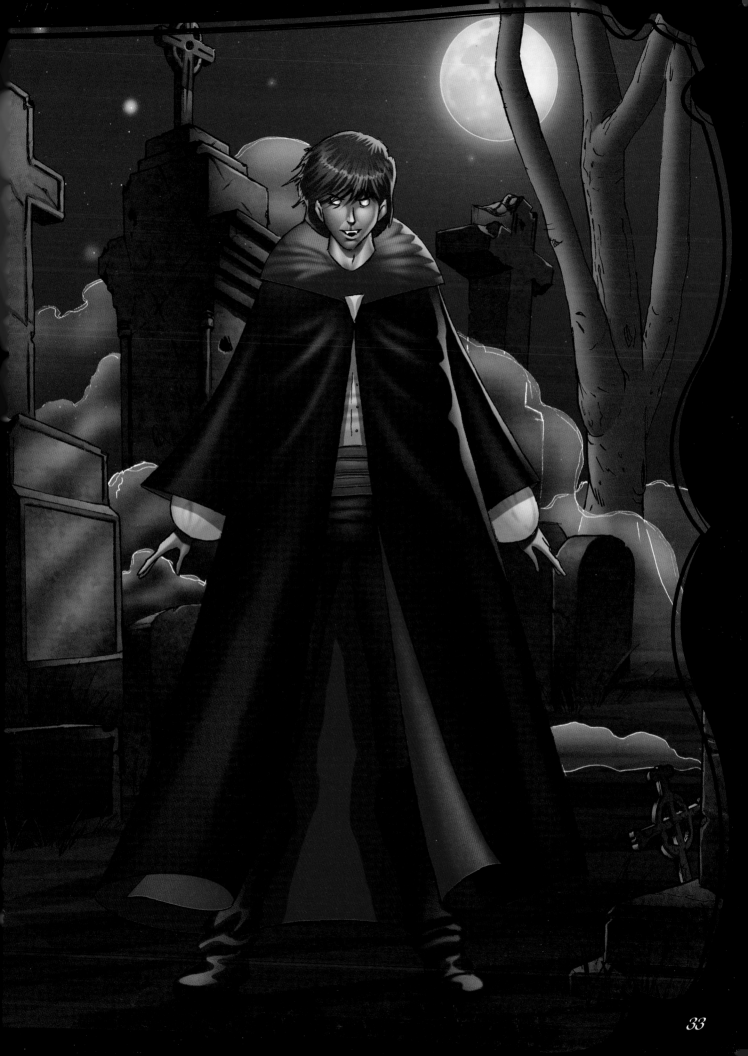

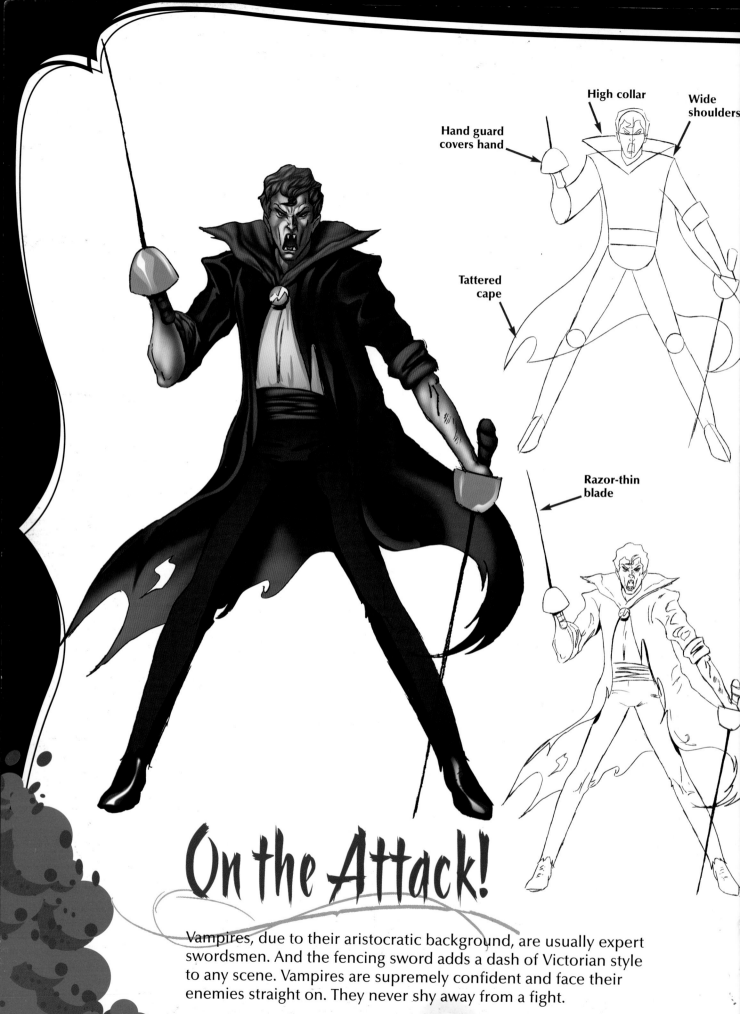

Hand guard covers hand

High collar

Wide shoulders

Tattered cape

Razor-thin blade

On the Attack!

Vampires, due to their aristocratic background, are usually expert swordsmen. And the fencing sword adds a dash of Victorian style to any scene. Vampires are supremely confident and face their enemies straight on. They never shy away from a fight.

The Night Visitor

Vampires are notorious for stealing into ladies' bedrooms at night to give them a good-night "kiss." Sometimes the only sign these nocturnal predators have entered is a gentle breeze and a flutter of the canopy. Here, a vampire stealthily approaches a woman as she sleeps. His powers begin to bring her toward him, even while she is still in her slumbering state.

Vampire on Throne

This is not your typical king's throne. The horns atop and the feet that resemble an animal's connote a world of darkness. Like most seated poses, this one calls for some significant *foreshortening*. See how short his thigh is compared to his lower leg? That's because the thigh is coming toward us and is therefore compressed, due to perspective, whereas the lower part of the same leg is drawn at full length because it is traveling off to the side.

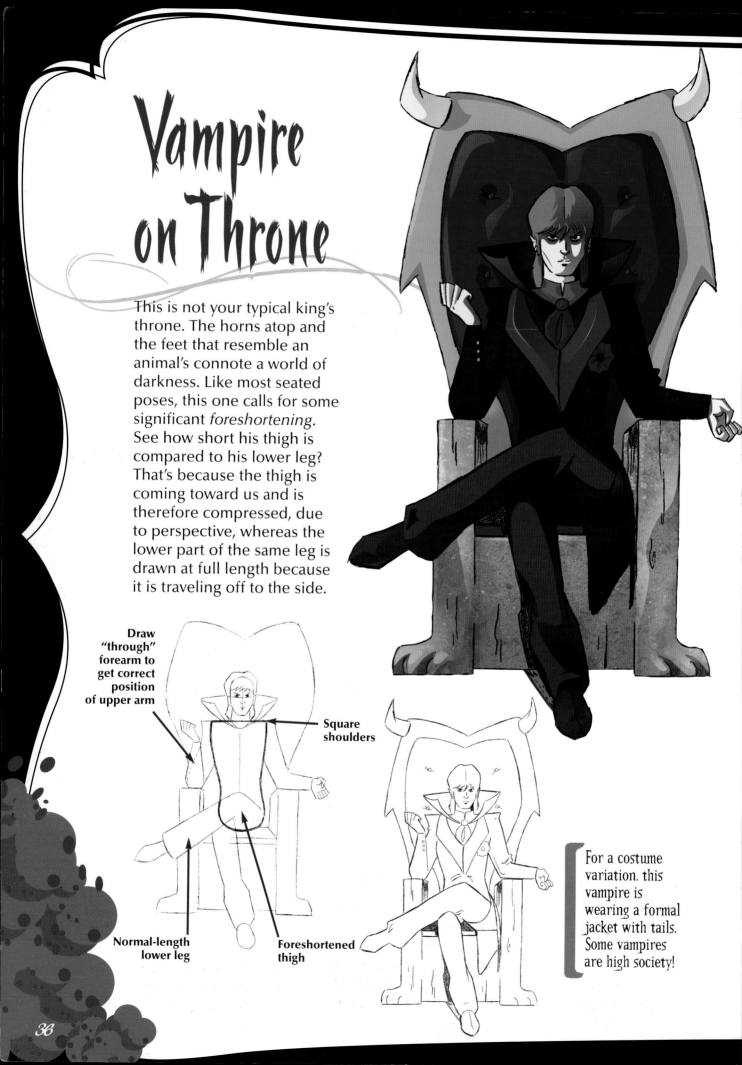

Draw "through" forearm to get correct position of upper arm

Square shoulders

Normal-length lower leg

Foreshortened thigh

For a costume variation, this vampire is wearing a formal jacket with tails. Some vampires are high society!

Cape Styles

Here are examples of the most popular types of capes. But there is no such thing as a "wrong" cape, so if you want to invent your own style, by all means get creative! The cape suggests a flamboyant character, but more than that, it is also a reference to bat wings. When a vampire isn't transformed into an ugly beast, the cape helps remind us that he's not entirely human.

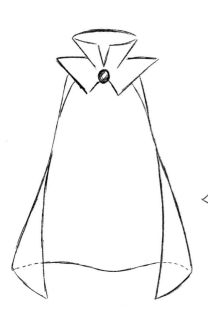

CLASSIC CAPE
Keep it simple with a triangular collar and a smooth hemline.

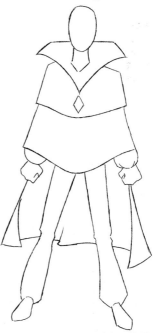

SCALLOPED HEMLINE
A slight variation on the classic, the hem on this cape mimics a bat's wings.

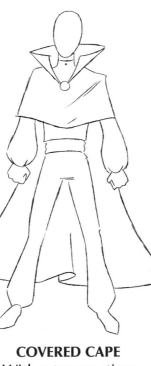

HIGH CIRCULAR COLLAR
Compare this style to the triangular collar shown on the classic cape.

COVERED CAPE
With a top portion that wraps around the vampire's shoulders, this cape allows less movement and is slightly more formal than the classic cape.

LAYERED CAPE
Adding another layer almost turns the cape into a coat.

Classic Cape Poses

Capes are used for more than just costume design. Since they can whip around the body, they are also employed to add a sense of action and to enhance body language and posture. Strive for long, sweeping lines when drawing these poses.

ARMS RAISED

It helps to rough out the body first. even if it will be hidden by the cape. In poses where the cape follows the contours of the body. it's imperative to get these shapes right.

HIDING IDENTITY

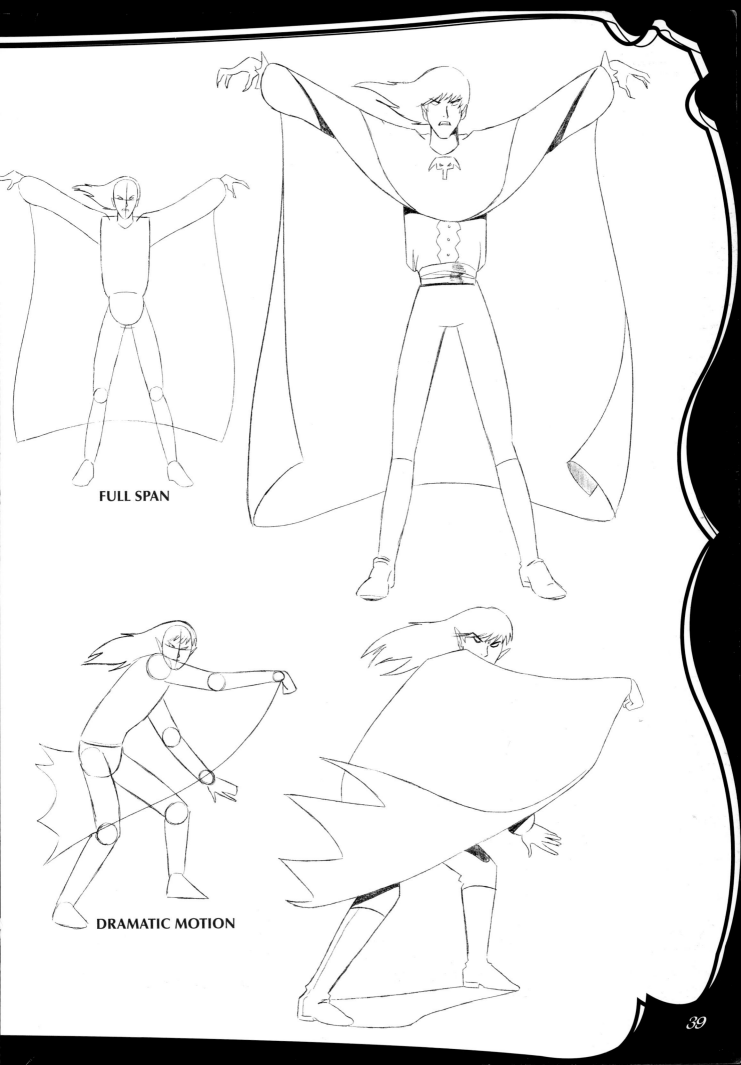

FULL SPAN

DRAMATIC MOTION

Vampire Flight

Some vampires can fly, but the really spooky look is when they float, just hovering outside your window in the night sky. In order to fly, they sometimes become bats (or other flying creatures, such as owls and flies). We'll cover a few of those cuddly critters a little later on.

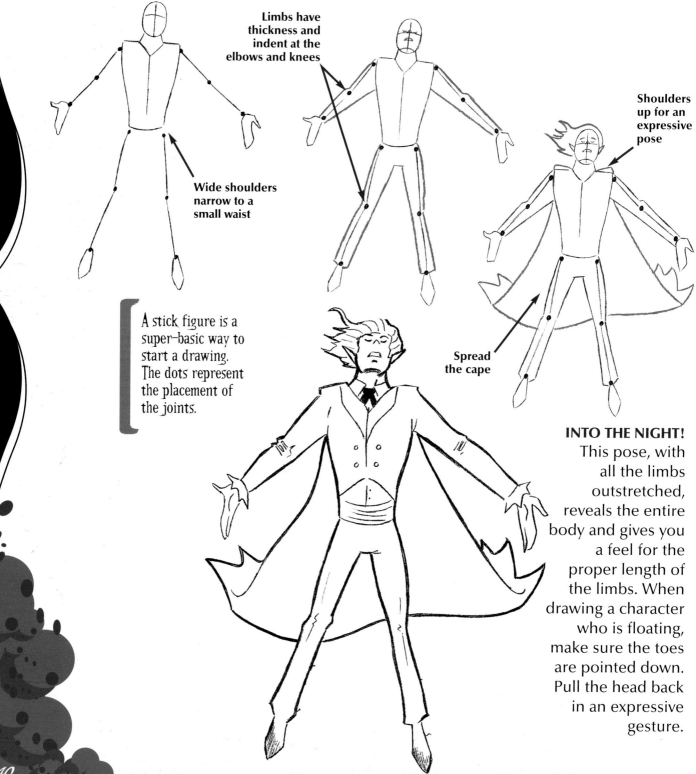

Limbs have thickness and indent at the elbows and knees

Wide shoulders narrow to a small waist

Shoulders up for an expressive pose

Spread the cape

A stick figure is a super-basic way to start a drawing. The dots represent the placement of the joints.

INTO THE NIGHT! This pose, with all the limbs outstretched, reveals the entire body and gives you a feel for the proper length of the limbs. When drawing a character who is floating, make sure the toes are pointed down. Pull the head back in an expressive gesture.

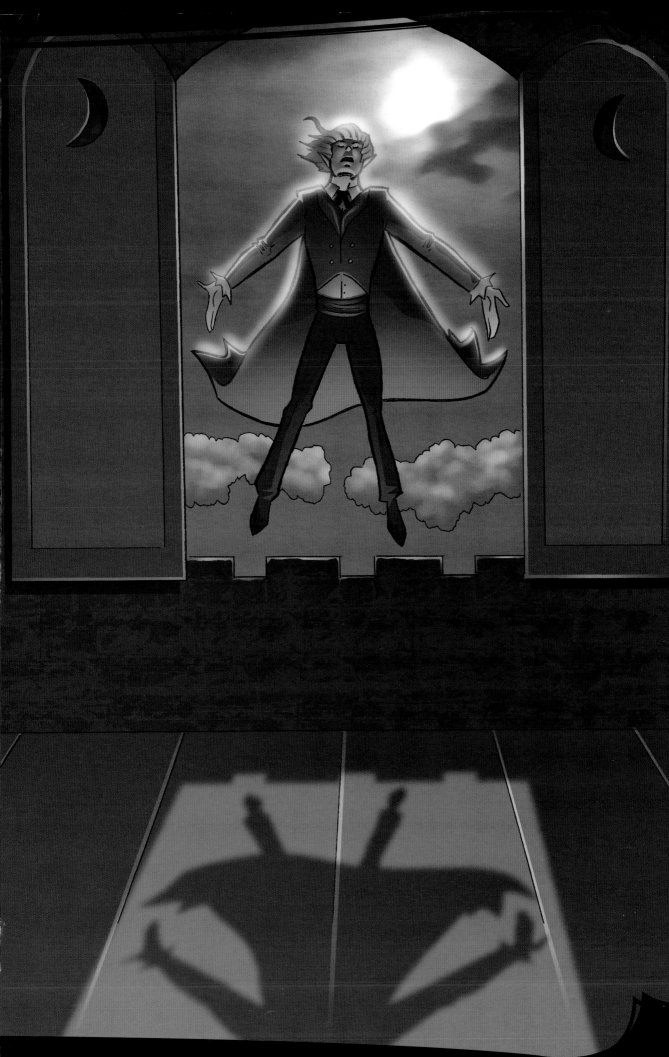

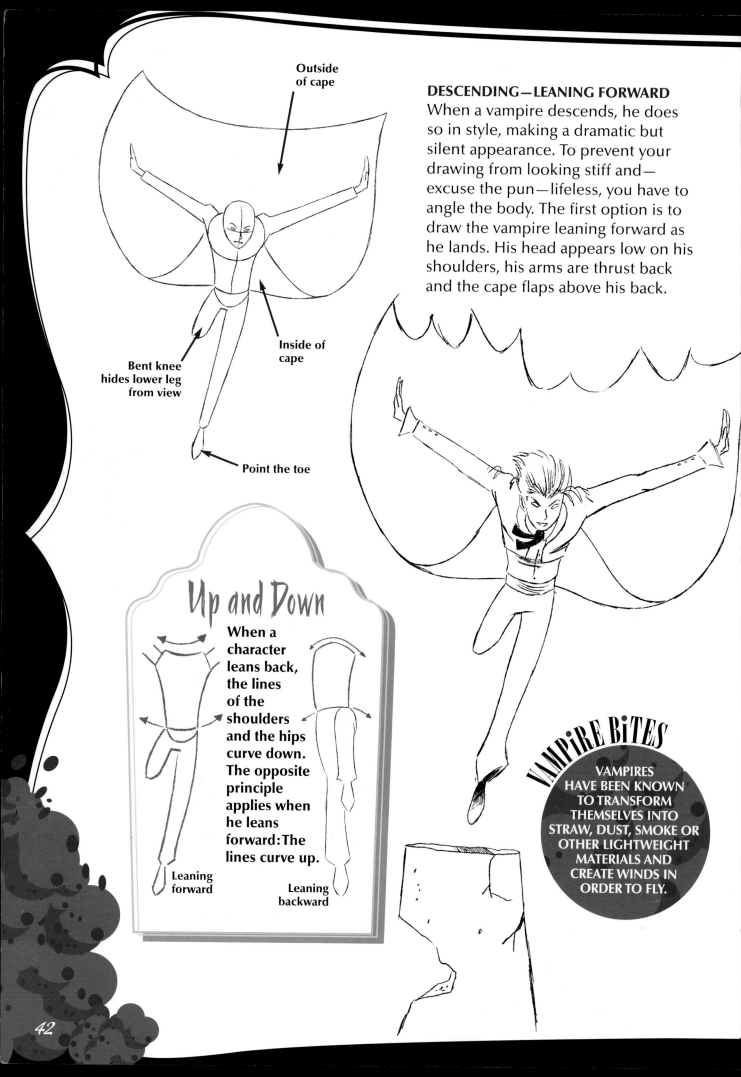

Outside of cape

Inside of cape

Bent knee hides lower leg from view

Point the toe

DESCENDING—LEANING FORWARD

When a vampire descends, he does so in style, making a dramatic but silent appearance. To prevent your drawing from looking stiff and—excuse the pun—lifeless, you have to angle the body. The first option is to draw the vampire leaning forward as he lands. His head appears low on his shoulders, his arms are thrust back and the cape flaps above his back.

Up and Down

When a character leans back, the lines of the shoulders and the hips curve down. The opposite principle applies when he leans forward: The lines curve up.

Leaning forward

Leaning backward

VAMPIRE BITES

VAMPIRES HAVE BEEN KNOWN TO TRANSFORM THEMSELVES INTO STRAW, DUST, SMOKE OR OTHER LIGHTWEIGHT MATERIALS AND CREATE WINDS IN ORDER TO FLY.

Shoulders up

Knee rises to height of waist

Front leg partially overlaps back leg

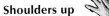

DESCENDING—LEANING BACK

In this pose, the vampire leans back as he returns to earth. The one-knee-up pose is always stylish. Tilt the head downward, so that he's looking where he's going, and allow the tie to trail behind and create the feeling that he's moving through space. The most dramatic element, however, by far, is the billowing cape, which starts at the waistline.

DEADLY BEAUTIES
Lady Vampires

The most seductive creatures in the gothic world would have to be vampire women. These femmes fatales can cast a spell over even the strongest of men. Beautiful but vicious—that's the right combination. We'll start with the head, then move on to full-body poses. As with any pretty female, the eyes, lips and hair are key. But for the vampiress, everything takes on a more severe tone. Let's enter her lair, shall we?

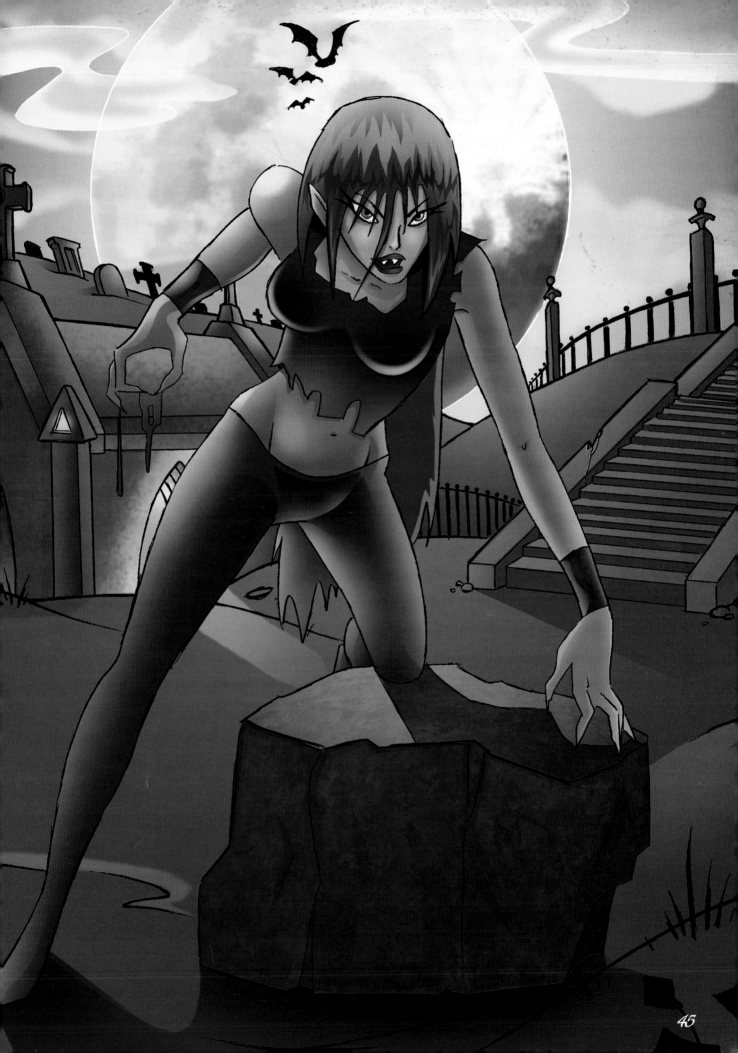

Classic Vampiress

To break down this front view into its more basic elements and make it easier to follow, draw a simple circle for the top of the head and a simple jaw beneath. The jaw is small and tapered but does not come to a point, as it does in manga drawings. Darken the outline of both eyes, elongating those spiky lashes. Really crush down on those eyes with the eyebrows. The hair is wavy and untamed. Last but certainly not least, give her some fangs!

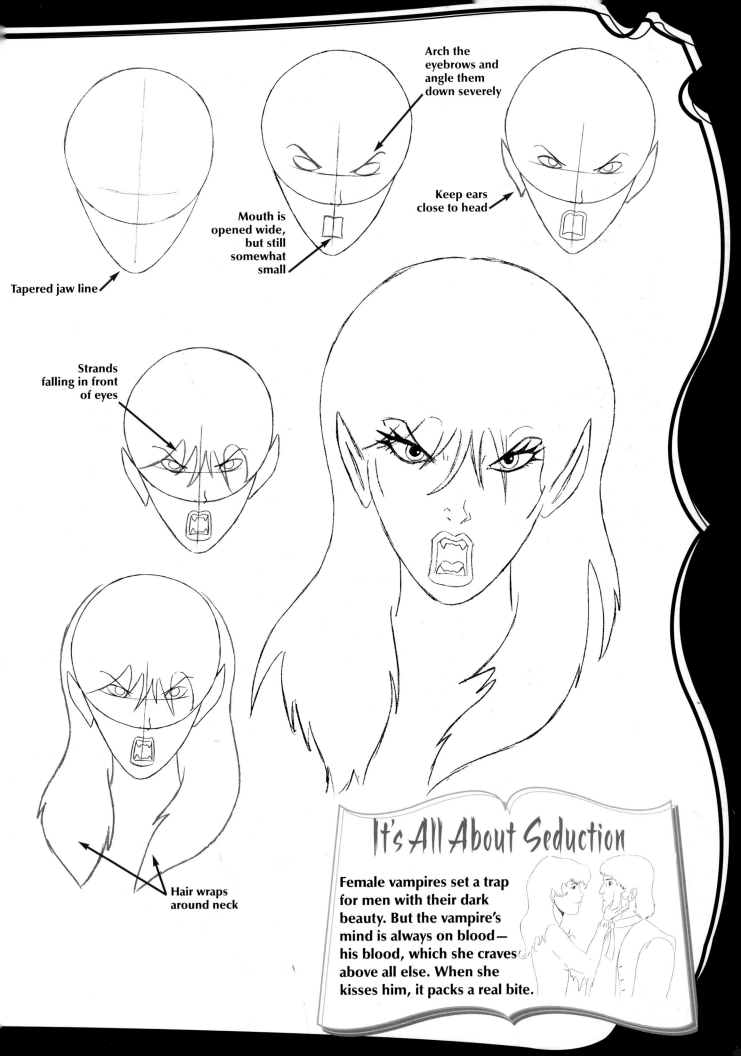

Arch the eyebrows and angle them down severely

Tapered jaw line

Mouth is opened wide, but still somewhat small

Keep ears close to head

Strands falling in front of eyes

Hair wraps around neck

It's All About Seduction

Female vampires set a trap for men with their dark beauty. But the vampire's mind is always on blood— his blood, which she craves above all else. When she kisses him, it packs a real bite.

Playful Vampire

This coy vampire gives us a good example of a 3/4 view. Unless the 3/4 view is turned far to one side, you should still be able to see both nostrils. But the lips have to angle in one direction—to the left in this case; they cannot stay in a front or near-front view. Allow the bangs to gently brush the tops of the eyes for a cool look.

VAMPiRE BiTES

TWENTY-FIVE YEARS BEFORE BRAM STOKER TERRIFIED THE WORLD WITH *DRACULA*, SHERIDAN LE FANU WROTE A NOVELLA ABOUT A FEMALE VAMPIRE, *CARMILLA*, WHICH IS SAID TO HAVE INFLUENCED STOKER'S CREATION.

Lips angle to the left

A long neck is attractive

Chin rests on neck

Tilting the head down makes it natural for her to look up. giving her large. bright eyes.

Brush all the strands of hair in the same direction

Lovely Lips

In the 3/4 view, the lips must angle left or right.

3/4 view, lips left **Front view, lips forward** **3/4 view, lips right**

Head Tilt

Pointing the chin out creates an inquisitive expression. Tilt it in for a playful look.

Inquisitive **Playful**

The more realistic you want your character to look. the more important it is to draw the pupil inside of an iris. rather than as one simple dot.

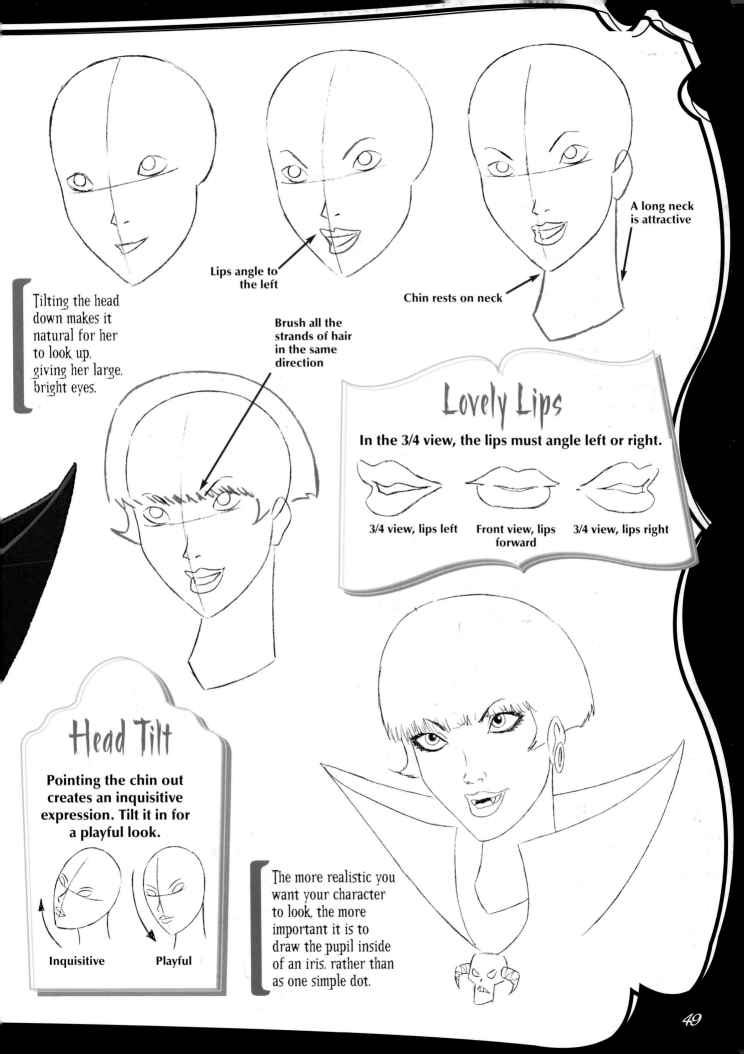

Shock & Awe

This wraithlike expression is great for vampires. The eyes are opened wide, for a look of shock. This is how she might appear immediately after changing from a normal-looking girl into a vampire. The future victim, of course, stands there witnessing the entire transformation, hypnotized by its awfulness. Why don't they ever run when they have the chance?

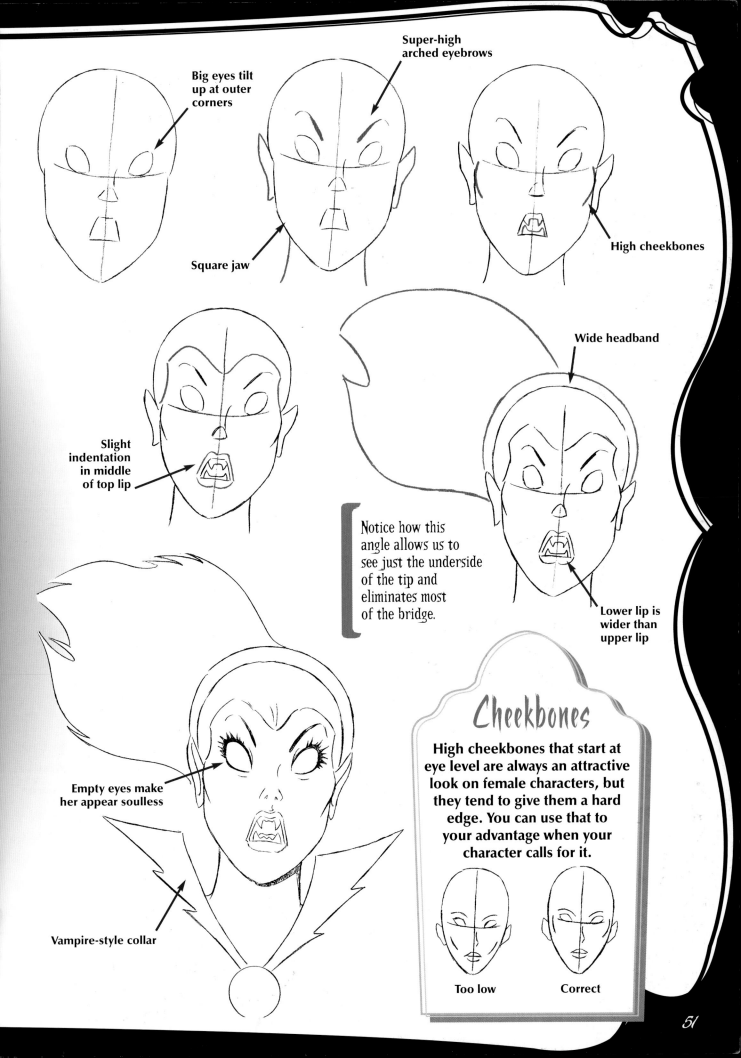

Big eyes tilt up at outer corners

Super-high arched eyebrows

Square jaw

High cheekbones

Slight indentation in middle of top lip

Wide headband

Notice how this angle allows us to see just the underside of the tip and eliminates most of the bridge.

Lower lip is wider than upper lip

Empty eyes make her appear soulless

Vampire-style collar

Cheekbones

High cheekbones that start at eye level are always an attractive look on female characters, but they tend to give them a hard edge. You can use that to your advantage when your character calls for it.

Too low

Correct

Sexy Vamp

To transform a regular gal into a creature of darkness, give her dark eyes, long hair and those crazy teeth. Add to that a body attitude that shows she's on the prowl.

Part of the appeal of female vampires is the conflicting feelings they provoke. Unlike the men, the women have to be attractive enough to be enticing, while still very, very dangerous. This combo creates an edgy look.

Body leans to one side

Head set low on shoulders

Wide hips

Arm acts as support

Balances on ball of foot

Vampire Bride

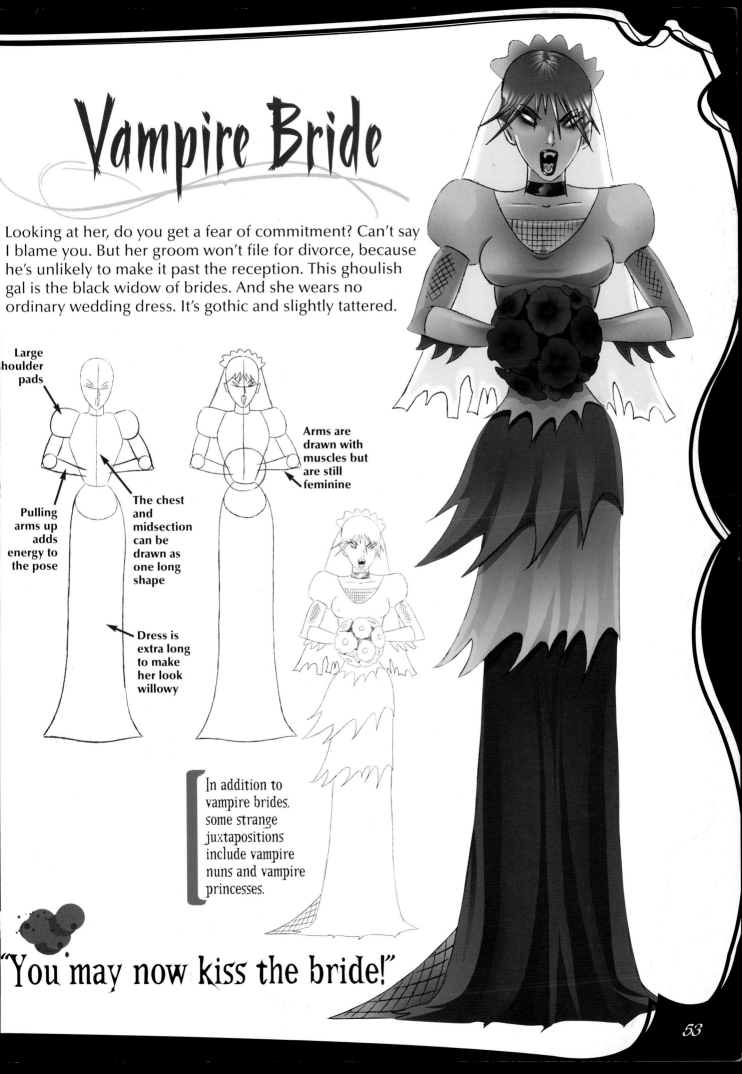

Looking at her, do you get a fear of commitment? Can't say I blame you. But her groom won't file for divorce, because he's unlikely to make it past the reception. This ghoulish gal is the black widow of brides. And she wears no ordinary wedding dress. It's gothic and slightly tattered.

Large shoulder pads

Pulling arms up adds energy to the pose

The chest and midsection can be drawn as one long shape

Arms are drawn with muscles but are still feminine

Dress is extra long to make her look willowy

In addition to vampire brides, some strange juxtapositions include vampire nuns and vampire princesses.

"You may now kiss the bride!"

The Deadbutante

Gliding just above the ground, this vampire haunts the castle halls. Her pose is wistful, strangely serene, and spooky yet inviting. Her palms face out, as if to receive guests—guests who will never leave! The long gloves give her a formal appearance. Even without her fangs showing, the wings make it pretty clear she's no ordinary belle of the ball—hell's belle is more like it!

Winging It

Wings, whether they belong to birds, bats, dragons or vampires, are similar. They have long spikes connected by skin flaps, and sometimes a short thumb-like claw. You can draw your vampire wings with three, four, even five spikes. Any variation will do.

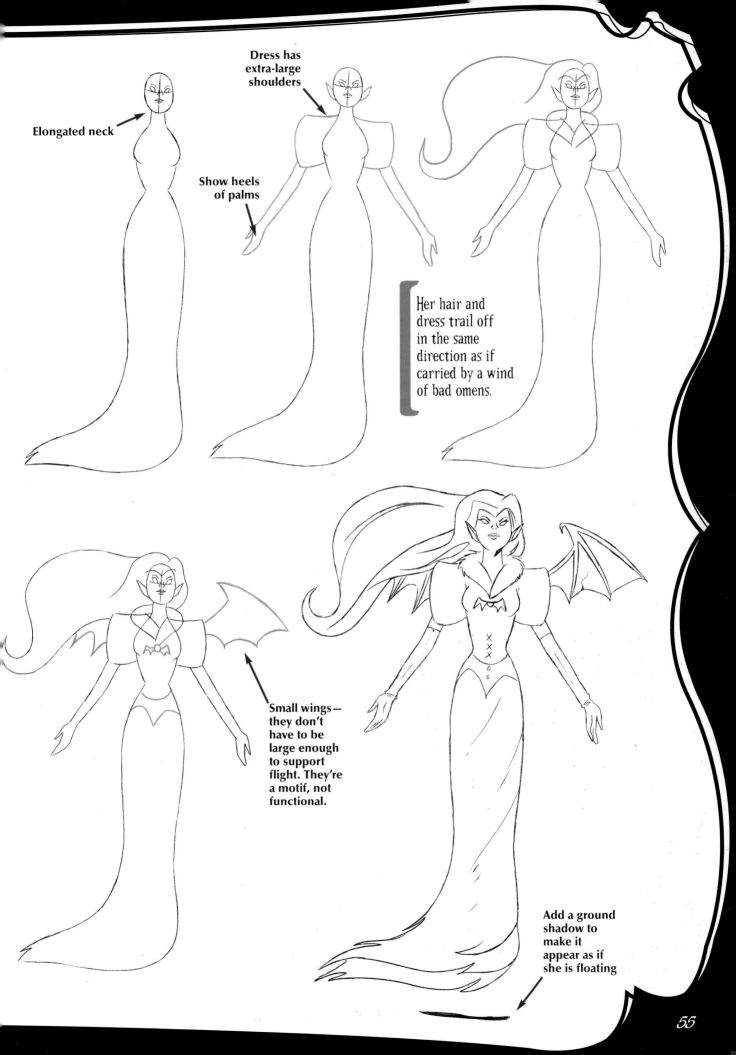

Elongated neck

Dress has extra-large shoulders

Show heels of palms

Her hair and dress trail off in the same direction as if carried by a wind of bad omens.

Small wings — they don't have to be large enough to support flight. They're a motif, not functional.

Add a ground shadow to make it appear as if she is floating

Thin waist

Curved hips

Hair curves as it cascades down the back

Shoulder placed low

Ghostly Vampire

This lovely specter haunts the castle merely by gliding through it. She has a very slinky shape and very long hair. Straight hair of this length is usually seen only on horror characters. Give her a long neck and make the eyes solid black for a haunting look.

Girl Vampire

Even the young can be possessed by the curse of the undead. Vampire children are especially creepy. It's effective to show them floating above the ground, hovering like ghosts. This one's cherubic, round face is belied by those haunting eyes. Her hair should be long and flowing, as if she were underwater.

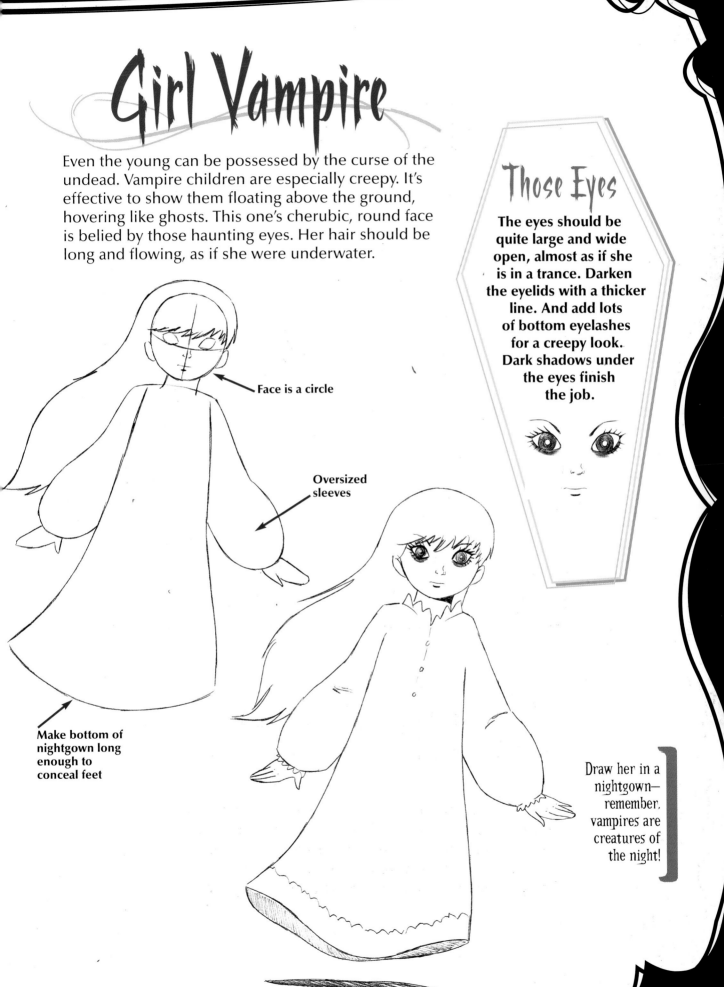

Face is a circle

Oversized sleeves

Make bottom of nightgown long enough to conceal feet

Those Eyes

The eyes should be quite large and wide open, almost as if she is in a trance. Darken the eyelids with a thicker line. And add lots of bottom eyelashes for a creepy look. Dark shadows under the eyes finish the job.

Draw her in a nightgown—remember, vampires are creatures of the night!

Vampire Bats

Bats and vampires are inextricably entwined in legend and lore. Vampires can transmogrify into and out of bat form at will, but even if you don't want to turn your vampire into a bat, it's a good idea to draw a few of these critters flying around your story. They are the absolute creepiest of animals. Ugly to the point of being unbearable, the bat can be used as a motif to make the scene more gothic and to convey imminent danger.

VAMPIRE BITES

MOST BATS EAT INSECTS, MAKING THEM BENEFICIAL TO HUMANS, BUT THERE ARE THREE SPECIES OF VAMPIRE BATS, WHICH FEED MOSTLY ON LIVESTOCK. THEIR SALIVA CONTAINS A SUBSTANCE THAT PREVENTS THE VICTIM'S BLOOD FROM CLOTTING, SO THEY DON'T ACTUALLY SUCK BLOOD, THEY JUST LAP IT UP. SOMEHOW I DON'T FIND THAT VERY COMFORTING.

Looking at the bat's head, you can see a strong resemblance to a gargoyle.

DRAWING THE HEAD

Bats look a lot like rats with wings. But rats are cuter, if you can believe it. The bat should look as creepy and evil as possible, so I like to exaggerate certain attributes—most of all the thick eyebrows, which actual bats don't have—to make the creature expressive.

The bat is a great springboard from which to create new types of beasts. Familiarize yourself with it. And it can become part of your inspiration.

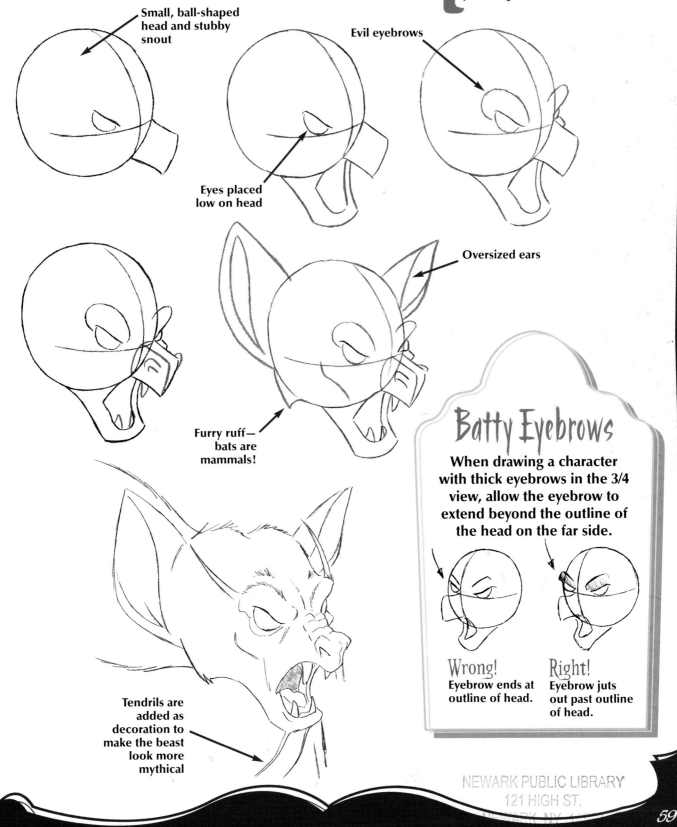

Small, ball-shaped head and stubby snout

Eyes placed low on head

Evil eyebrows

Oversized ears

Furry ruff—bats are mammals!

Tendrils are added as decoration to make the beast look more mythical

Batty Eyebrows

When drawing a character with thick eyebrows in the 3/4 view, allow the eyebrow to extend beyond the outline of the head on the far side.

Wrong!
Eyebrow ends at outline of head.

Right!
Eyebrow juts out past outline of head.

FLYING BAT

The bat's forelegs are skinny at the base and turn into wings as they go up. The body is puffy, like a round plush toy. But lest ye think that means it's cute, take a look at that face. That is one ugly flying critter.

Place the head well down between the shoulders

Add mass to the back of the shoulders

Large wingspan

It's also correct to hide the hind legs and tail in this straight-on flying pose, but I think that dangling them behind the body helps clarify the form.

BAT VARIATIONS

Here are a few more bat poses, close-ups and angles. One thing to keep in mind: If you silhouette the bat, leave off the feet and tail, but heavily "scallop" the bottoms of the wings. It's not only a cleaner look, but it reads more clearly as a bat.

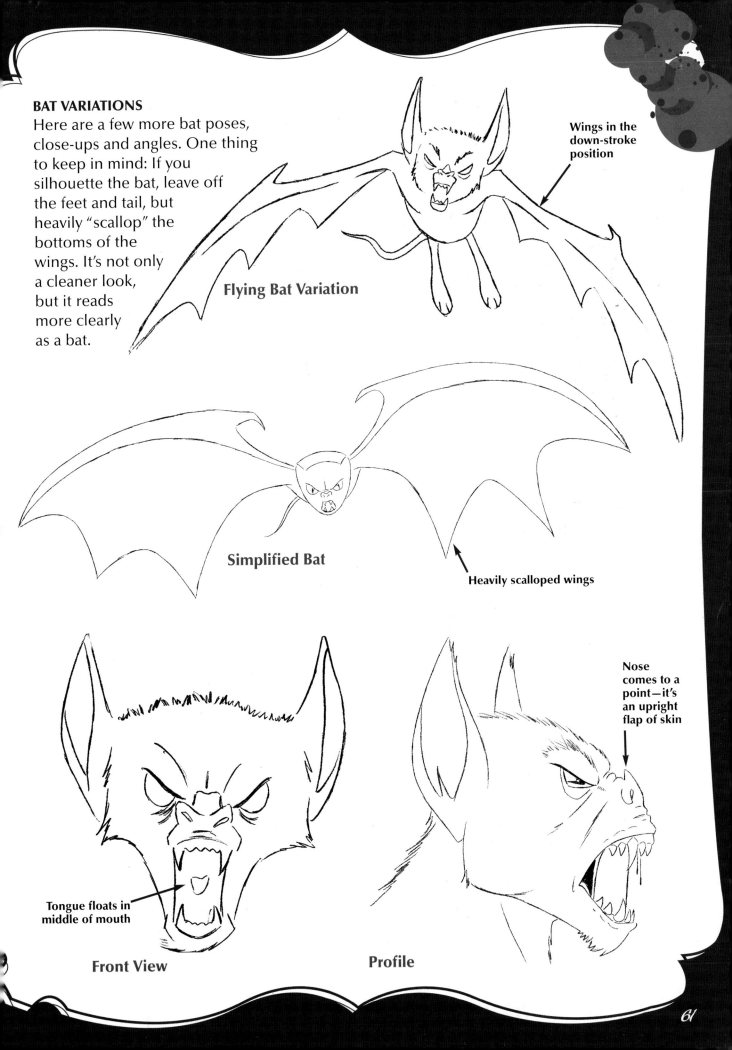

Wings in the down-stroke position

Flying Bat Variation

Simplified Bat

Heavily scalloped wings

Nose comes to a point—it's an upright flap of skin

Tongue floats in middle of mouth

Front View

Profile

BEYOND SCARY
Otherworldly Vampires

The trend in vampire art today is to push the envelope in character designs. Artists often take basic vampires and transform them into terrifying night stalkers with horns, wings and other animalistic features—otherworldly creatures that still read as vampires. These cursed beings are in some ways even more frightening than the original versions. They're from the world of nightmares.

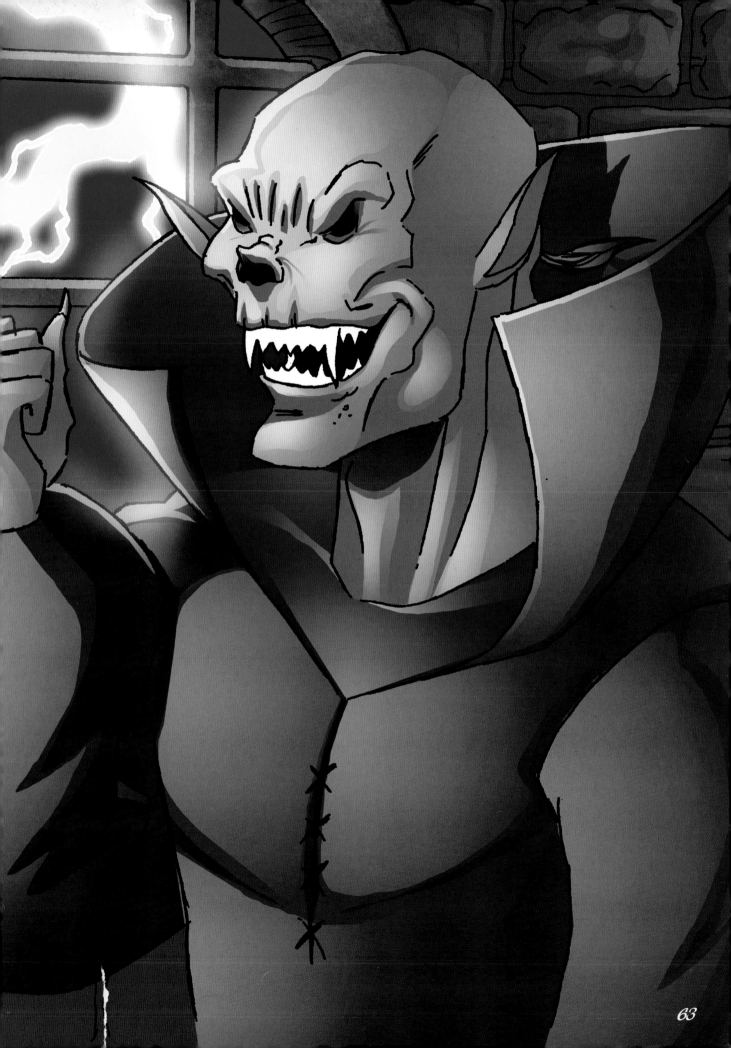

Ancient Vampire

His weathered face clues us in to his eternal life as one of the undead.
He has a distinctive head shape—angular with wide cheekbones. His eyes
are small, a sign of advanced age. This creaky look is a popular one on
vampires, who have been reported to live for hundreds of years.
And what a difference a couple of horns make.

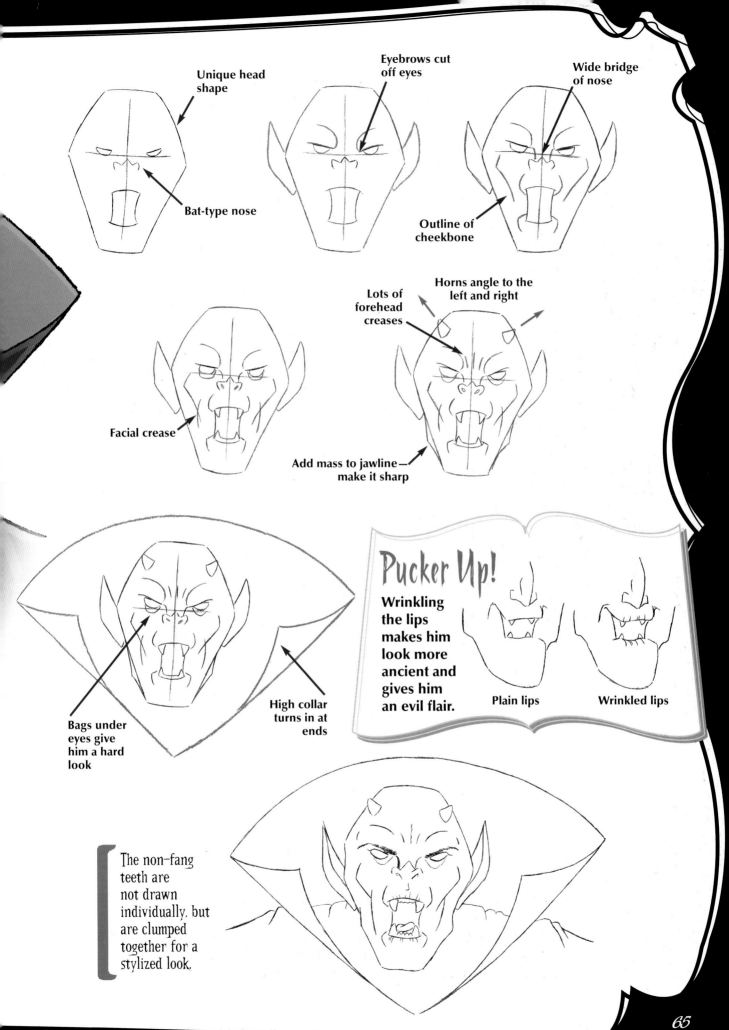

Unique head shape

Bat-type nose

Eyebrows cut off eyes

Wide bridge of nose

Outline of cheekbone

Facial crease

Lots of forehead creases

Horns angle to the left and right

Add mass to jawline— make it sharp

Bags under eyes give him a hard look

High collar turns in at ends

Pucker Up!

Wrinkling the lips makes him look more ancient and gives him an evil flair.

Plain lips

Wrinkled lips

The non-fang teeth are not drawn individually, but are clumped together for a stylized look.

Grotesque Vampire

Anyone with chin-horns is evil. Take my word on this. Eyes that pop out create intensity. And anytime you have a wide skull on a malevolent character, you'll want to give him or her wide cheekbones, which highlight the severe look—so important for the wicked. Follow it up with sunken cheeks for a grave effect.

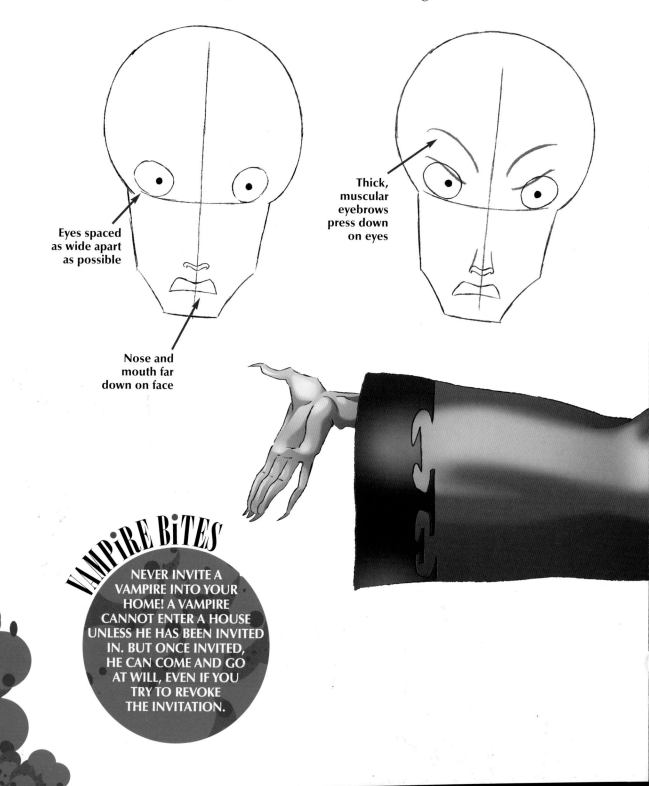

Eyes spaced as wide apart as possible

Nose and mouth far down on face

Thick, muscular eyebrows press down on eyes

VAMPIRE BITES

NEVER INVITE A VAMPIRE INTO YOUR HOME! A VAMPIRE CANNOT ENTER A HOUSE UNLESS HE HAS BEEN INVITED IN. BUT ONCE INVITED, HE CAN COME AND GO AT WILL, EVEN IF YOU TRY TO REVOKE THE INVITATION.

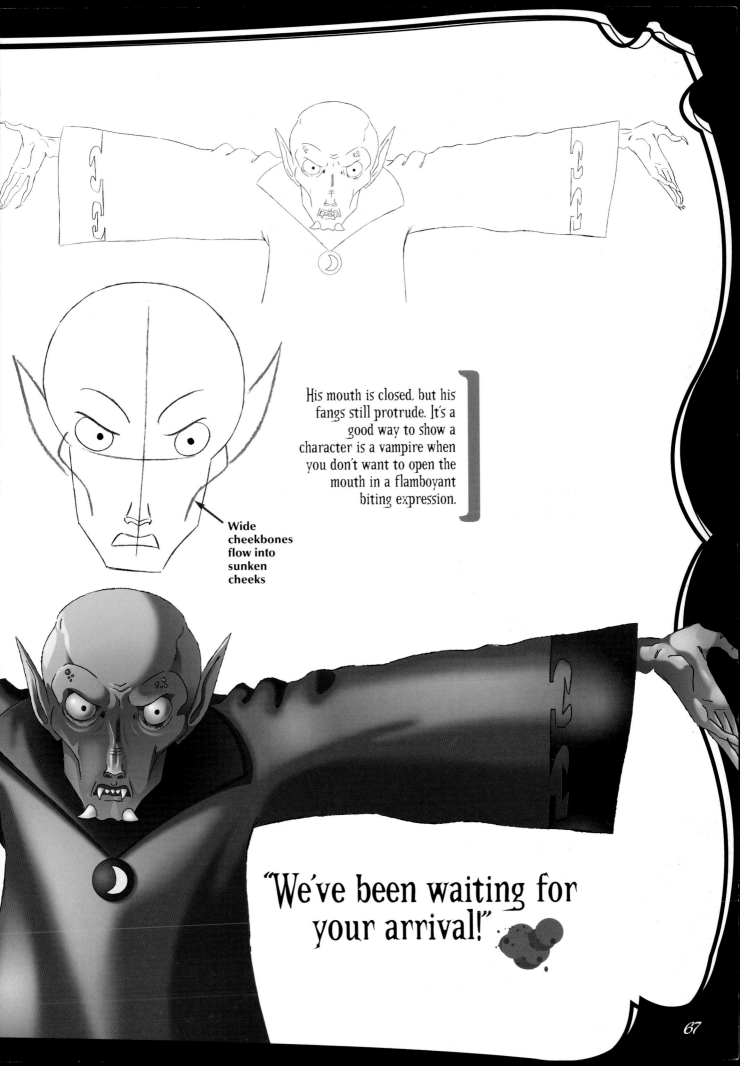

His mouth is closed, but his fangs still protrude. It's a good way to show a character is a vampire when you don't want to open the mouth in a flamboyant biting expression.

Wide cheekbones flow into sunken cheeks

"We've been waiting for your arrival!"

Skull-Faced Vampire

This guy easily takes the prize for creepiest vampire. He's an ancient fellow, who has neglected to use any face cream over the years. Believe me, a little moisturizer would have helped immensely.

Creepy Eyes

Bat-style eyes give him an especially ghoulish look. On humans, the eyes are usually spaced a single eye-length apart. But this doesn't hold true when drawing fantasy characters. In fact, the smaller the fantasy eyes, the farther apart they can comfortably be set.

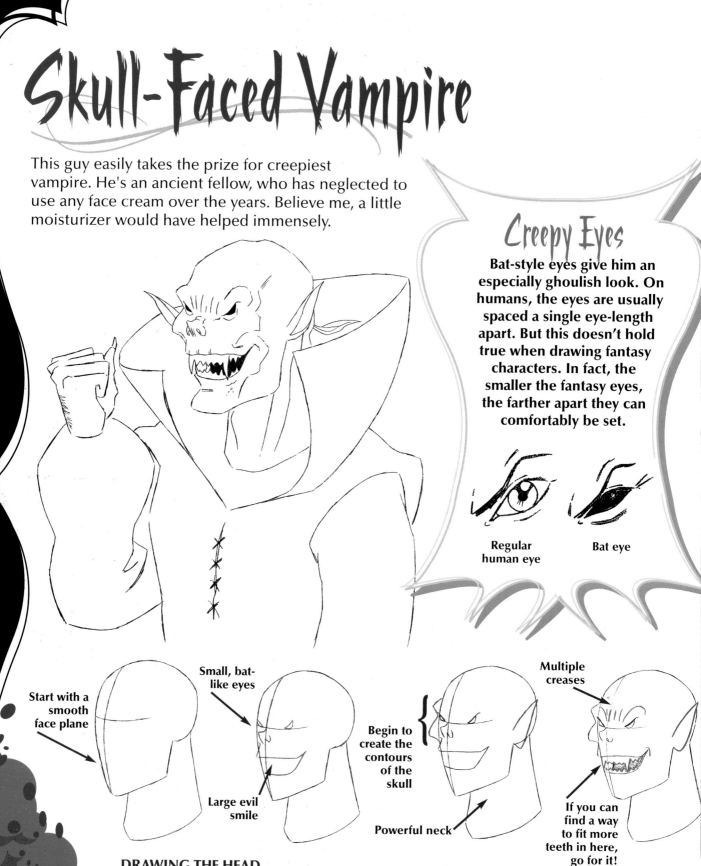

Regular human eye

Bat eye

Start with a smooth face plane

Small, bat-like eyes

Large evil smile

Begin to create the contours of the skull

Powerful neck

Multiple creases

If you can find a way to fit more teeth in here, go for it!

DRAWING THE HEAD

His head is the shape of a skull with some skin pulled tightly over it. Give him a bat-like nose and a super-wide face full of teeth, which are visible because there are no lips to cover them. He's got a thick neck, signifying that he's a powerful character, and not just a bag of bones.

Keep those vampire fingernails unmanicured!

Rough Pencil Sketch

Because the outline of the robe cuts such a strong silhouette, there is no need to sketch the underlying body first.

FULL-BODY POSE
Robes are often thought of as costumes for skinny characters, like wizards. But they're also very effective when filled out by a powerful figure. As he leans forward aggressively, his entire head is framed within the high collar, so it almost looks as if it is floating—a cool look.

Detail of facial construction

The fist is a group of flat planes

King of the Vampires

Oversized bat ears

This ruler of the undead is a brutal warlord commanding an army of ghastly bloodsuckers. He's a powerful leader known for his ruthlessness. He has no mercy for his enemies or for servants who don't obey his commands quickly enough! Give him a robe and staff to show his stature, but skip the crown. It's not necessary, and it's too medieval—a little corny for a vampire.

Beastly feet

This massive vampire should really fill out his robe, especially around the shoulders and chest area.

Creepy Accoutrements

No ordinary crown jewels will do for this otherworldy monarch. His gothic accessories feature ghoulish symbols of the underworld.

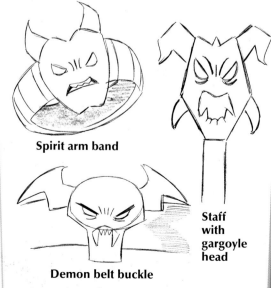

Spirit arm band

Staff with gargoyle head

Demon belt buckle

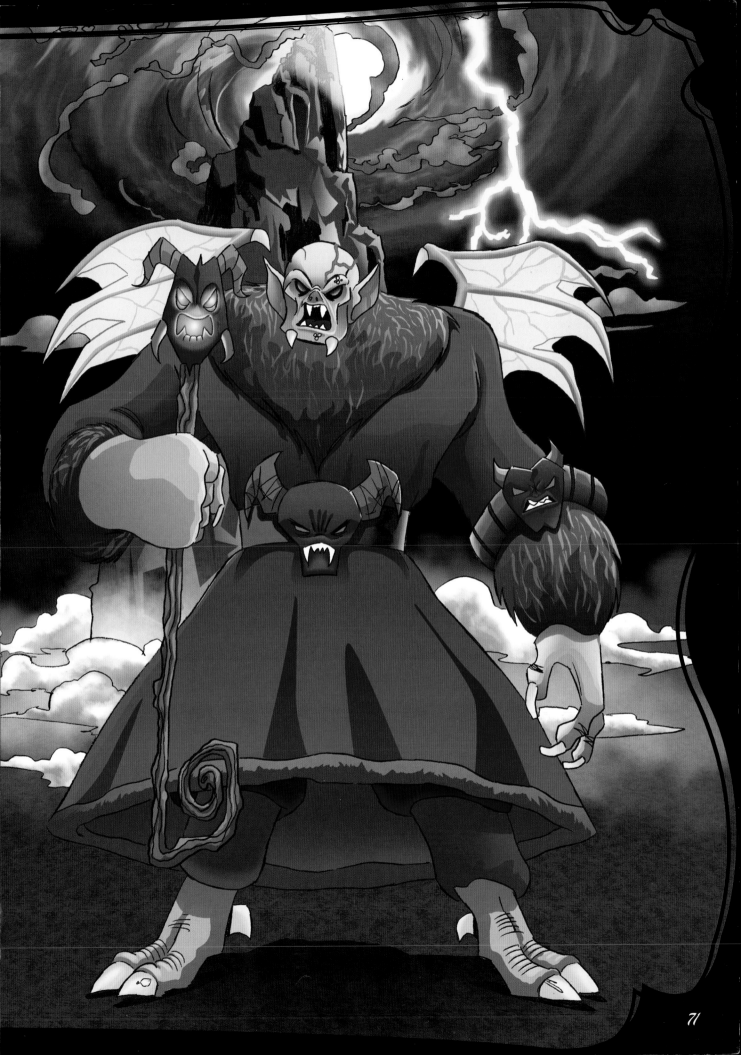

Super-Muscular Vampires

All vampires are strong, but a popular trend is to draw vampires with superhuman strength. These brutes have huge, sculpted muscles. They like to bite, but first they enjoy tossing a few humans into buildings. They make effective villains in a variety of stories.

FULL-BODY POSE

The typical brute vampire has a huge upper body and short tree-trunk legs. The posture is hunched over, as if the shoulders are so massive they actually cause the back to curve. Bony protrusions running the length of the spine add to his primitive look. Why the tail? Some bats have tails, so this further suggests his vampire associations.

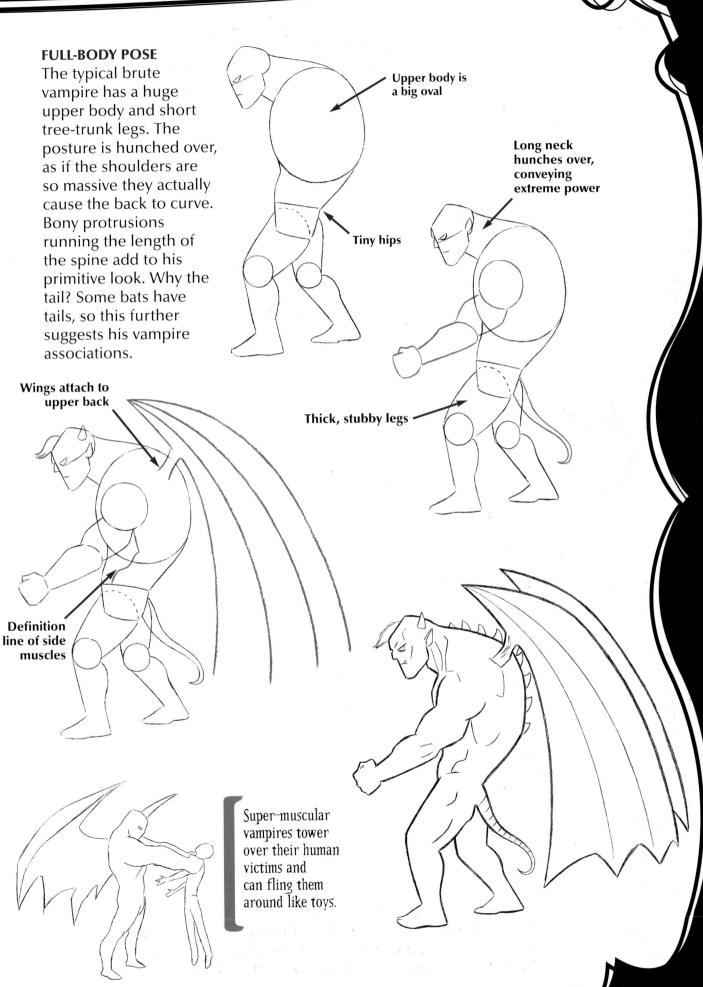

Upper body is a big oval

Tiny hips

Long neck hunches over, conveying extreme power

Thick, stubby legs

Wings attach to upper back

Definition line of side muscles

Super-muscular vampires tower over their human victims and can fling them around like toys.

SUPER-MUSCULAR VAMPIRE IN FLIGHT

This is a highly compressed shot of the muscular type of vampire flying straight at us. This drawing might look challenging at first, but this is actually one of the easiest perspective poses to draw. Overlapping the sections of the body—the chest muscles, the rib cage and the stomach—is the key to making it work. Let's take a look.

Shoulders overlap upper arm muscles

Bottom of chest wall

Bottom of rib cage

Bottom of stomach

Here's the most important thing to remember: Draw the chest big. the rib cage smaller and the stomach smaller still.

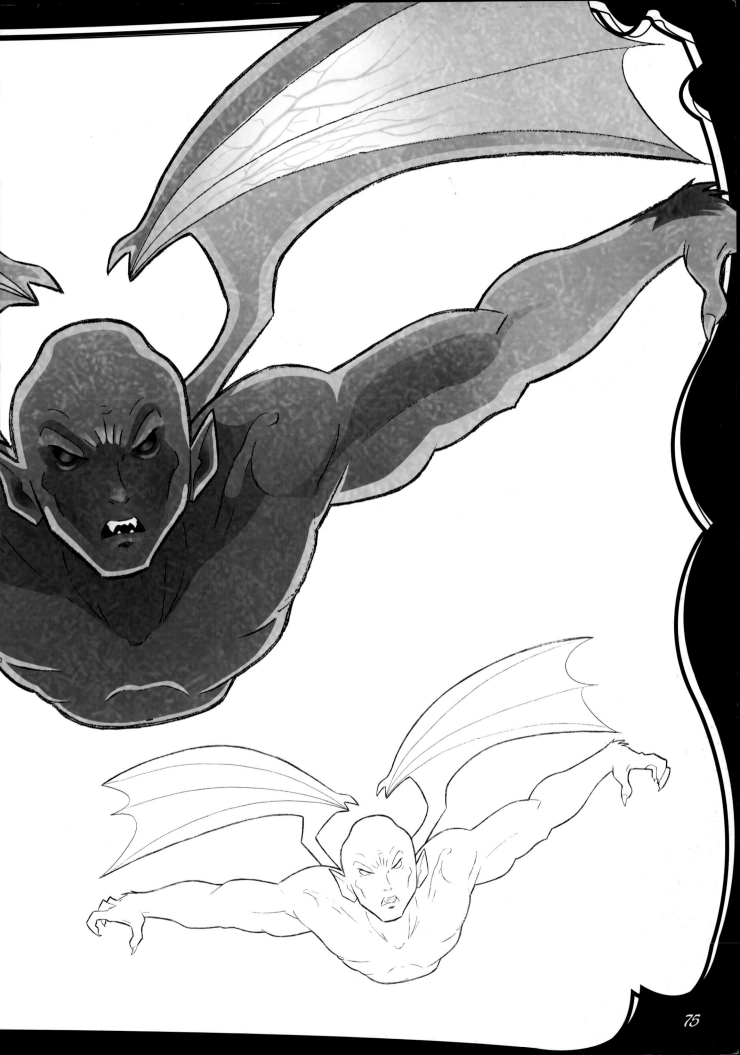

Vampires & Sleep

Even the undead need their beauty sleep. Vampires are active at night and sleep during the day, so they need to find a place to rest where they are hidden away and protected.

HANGING UPSIDE DOWN

Bats sleep hanging upside down, and some vampires do, too. Caves, attics and dungeons are good settings in which to draw a vampire in this pose. To give a feeling of being upside down, allow the hair to fall toward the ground. His wings wrap around him like a cloak.

It's unnecessary to draw the figure upside down. Simply draw it upright and turn the page over when you're done!

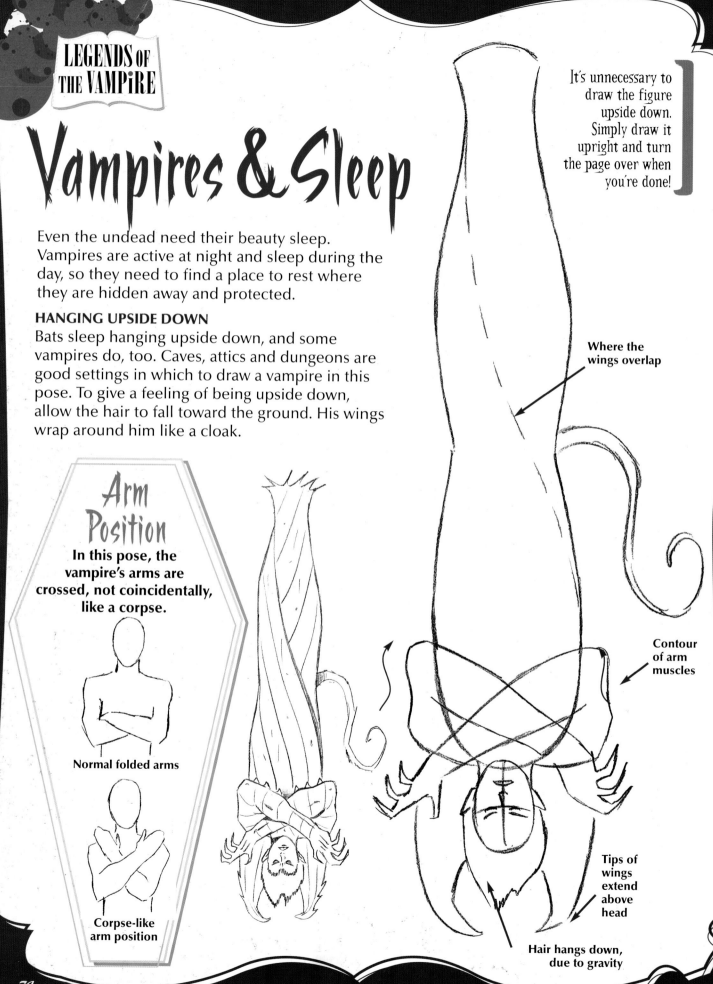

Arm Position

In this pose, the vampire's arms are crossed, not coincidentally, like a corpse.

Normal folded arms

Corpse-like arm position

Where the wings overlap

Contour of arm muscles

Tips of wings extend above head

Hair hangs down, due to gravity

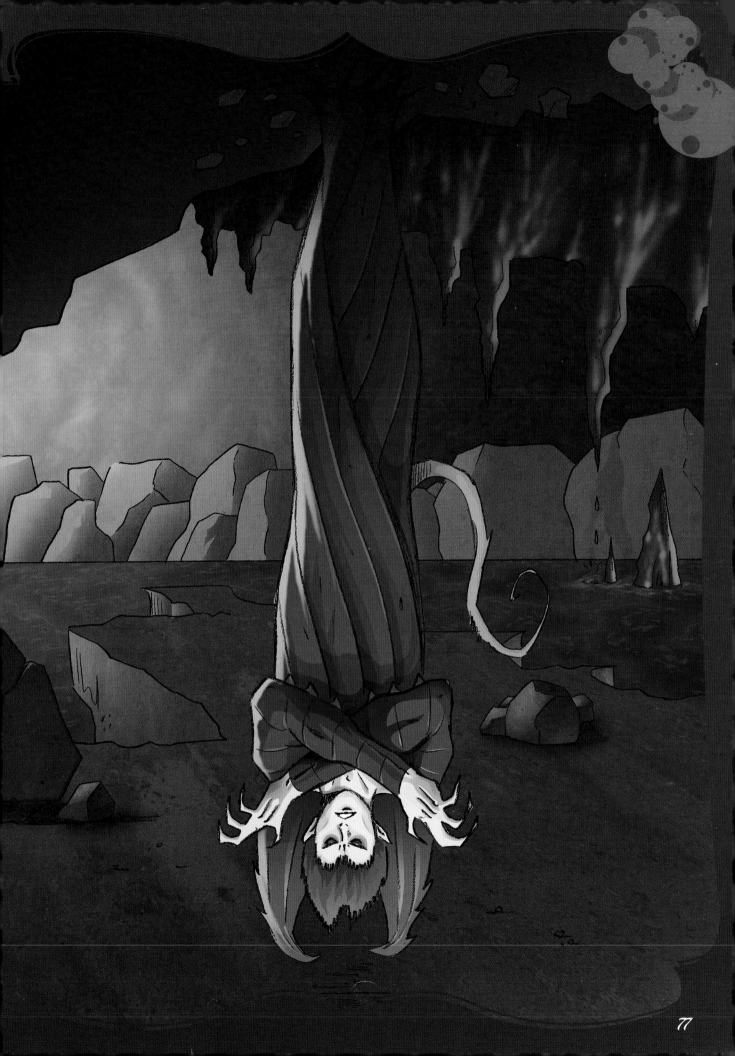

THE COFFIN

This is the vampire's version of a bunk bed, where he feels most comfortable getting a little shut-eye. It should look tight in there. Is "cozy" the right word?

Tops of shoulders create their own plane

Side of figure visible at this angle

Upper thigh foreshortened due to perspective

Supporting arm props him up; hand is masked by body

Note angle of curve above boot

Perspective

In this shot, we are looking down at the character, so we see the tops of his shoulders and knees. At this angle, the vampire and the coffin must be drawn in perspective. The farther something is from the reader, the smaller it appears, which means the front of the coffin should be drawn wide and the far end narrow. This is also why the vampire's torso diminishes as it travels down to his hips.

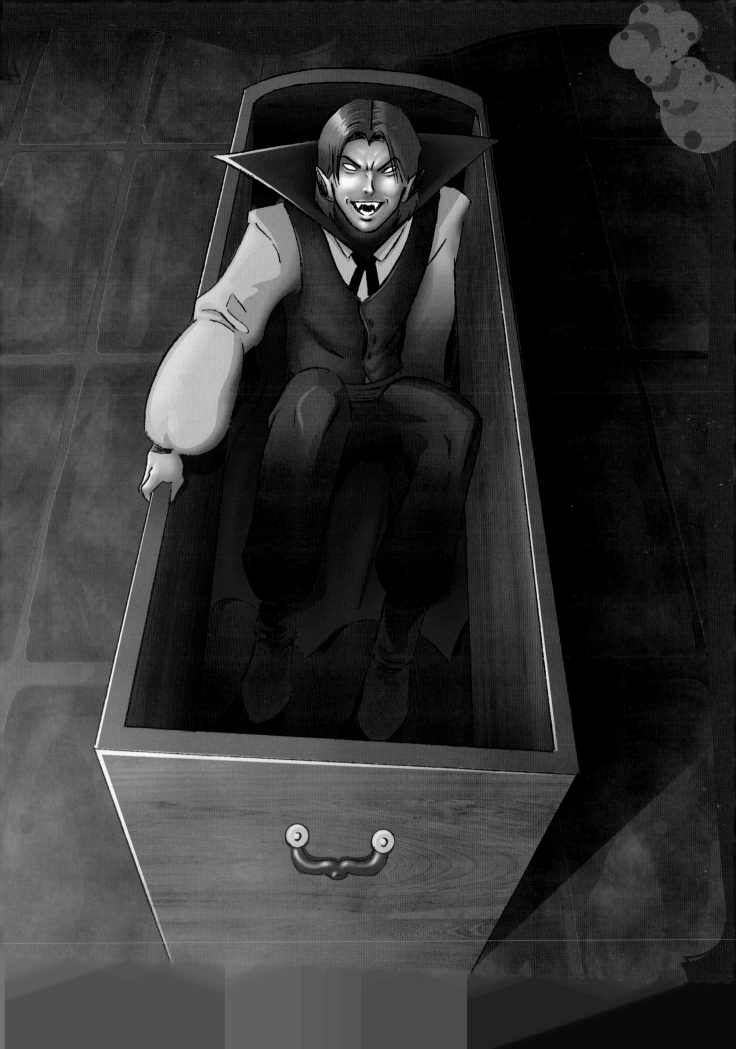

Postmodern Vampires

There are vampires among us. You can find lots of them in the fashion industry, because they are just so cool. Some of them look for "dates" on Internet matchmaking sites. But all of them are night owls, as the sunlight destroys them. So the next time you see an urban fashion plate someplace late at night, take special care. And pull your collar up high over your neck. No need to make yourself more tempting!

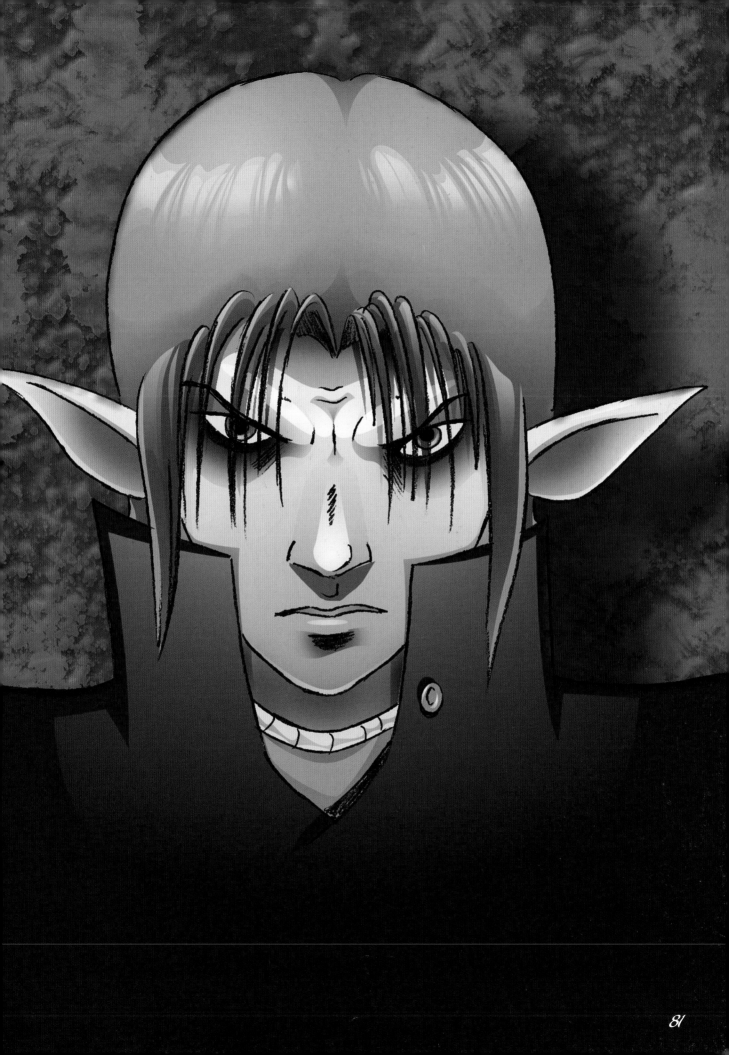

Night Dweller

This long-haired male vampire is a typical character in modern urban vampire stories. He's strong and lean with high cheekbones, and is never seen without his shades.

"I wear my sunglasses at night."

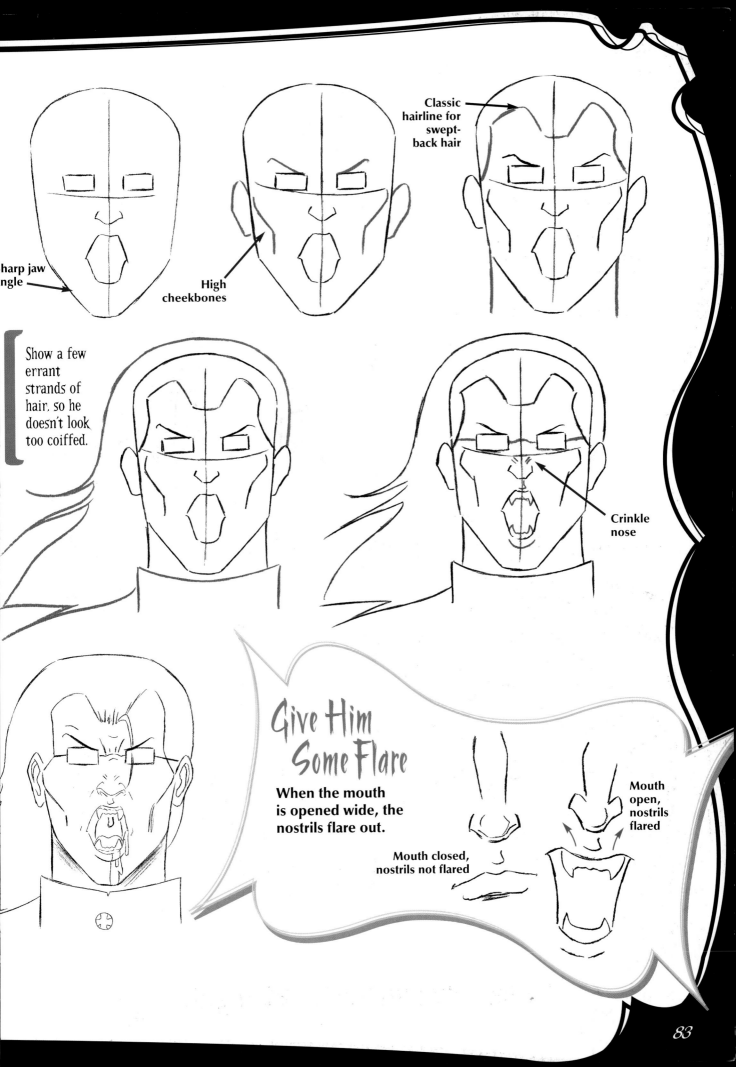

harp jaw ngle

High cheekbones

Classic hairline for swept-back hair

Show a few errant strands of hair, so he doesn't look too coiffed.

Crinkle nose

Give Him Some Flare

When the mouth is opened wide, the nostrils flare out.

Mouth closed, nostrils not flared

Mouth open, nostrils flared

Cool Ghoul

He cuts a romantic silhouette, mysterious and lonely. He's got a tall, slender build and often wears a trenchcoat or some other dark, urban-style outfit. The crew cut is an extreme look, as are the aviator-type sunglasses. I've added a hint of fangs and telltale vampire-style ears to further set him apart from your average downtown guy.

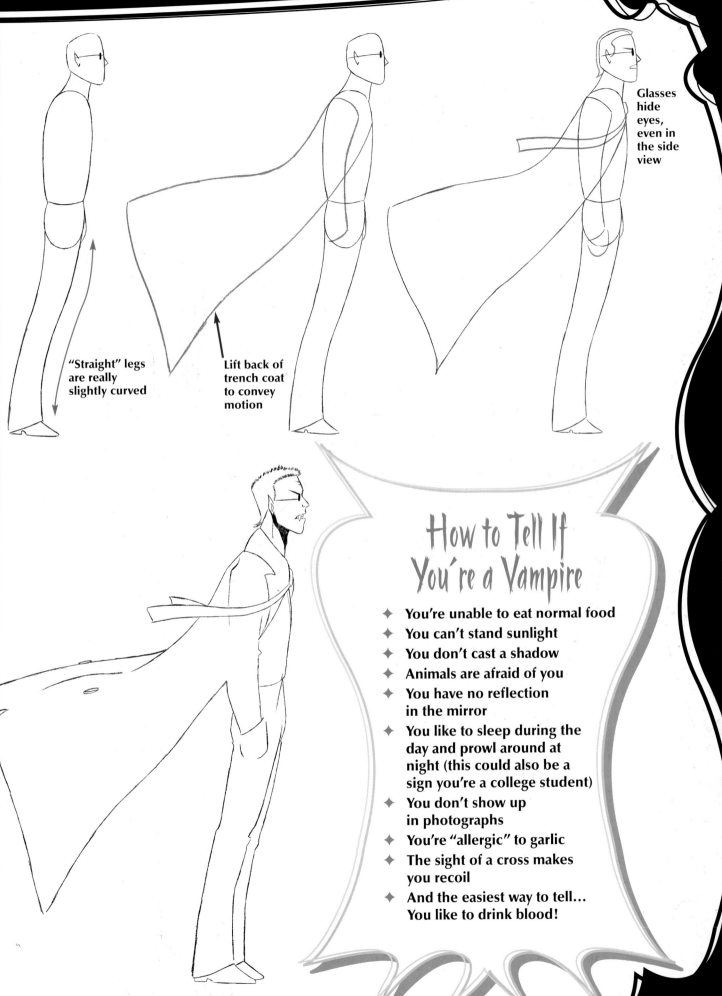

"Straight" legs are really slightly curved

Lift back of trench coat to convey motion

Glasses hide eyes, even in the side view

How to Tell If You're a Vampire

✦ You're unable to eat normal food
✦ You can't stand sunlight
✦ You don't cast a shadow
✦ Animals are afraid of you
✦ You have no reflection in the mirror
✦ You like to sleep during the day and prowl around at night (this could also be a sign you're a college student)
✦ You don't show up in photographs
✦ You're "allergic" to garlic
✦ The sight of a cross makes you recoil
✦ And the easiest way to tell... You like to drink blood!

Drawing Dripping Liquid

Whether it's blood, saliva or any other "goo," there's an optimal way to show it dripping. Do not draw dripping liquid as individual droplets, because that will read as water. Group the drops together so they look nice and sticky.

Individual drops One gooey mess

Punk Vampire

You might run across women like her on the New York subway between 1 and 4 a.m. They're angry and intense and look like they haven't seen daylight in years. Some of them are vampires, but the others are probably just as dangerous! Give her spiked hair for an urban punk look. Mess up the eyes with too much mascara. And a little "goo" dripping from the tongue never hurt.

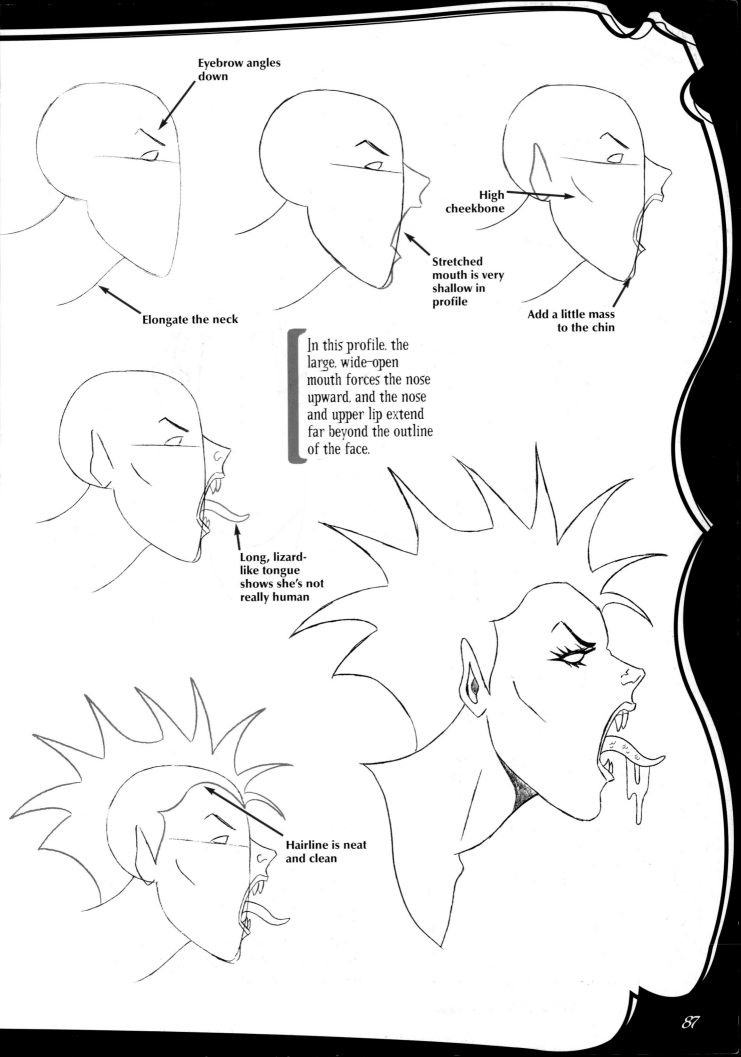

Eyebrow angles
down

Elongate the neck

Stretched
mouth is very
shallow in
profile

High
cheekbone

Add a little mass
to the chin

In this profile, the
large, wide-open
mouth forces the nose
upward, and the nose
and upper lip extend
far beyond the outline
of the face.

Long, lizard-
like tongue
shows she's not
really human

Hairline is neat
and clean

I Was a Teenage Vampire

Modern vampires are usually youthful characters, sometimes even young teens. They're rebels, misfits. And because of that, the reader relates to them. The most iconic feature of the young adult vampire is his dark eyes. He should look like he's been pulling all-nighters all month.

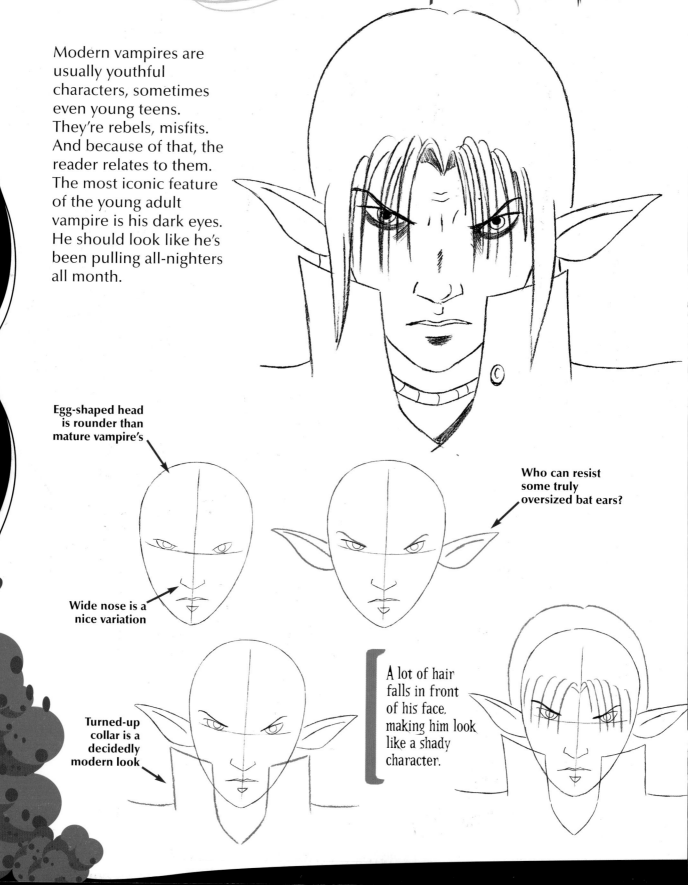

Egg-shaped head is rounder than mature vampire's

Who can resist some truly oversized bat ears?

Wide nose is a nice variation

Turned-up collar is a decidedly modern look

A lot of hair falls in front of his face, making him look like a shady character.

A Boy and His Bat

Like the pet bat? It perches on his arm like a bird of prey with a falconer. This young teen should look like he's never seen the sun—because he hasn't! The spiked hair gives him an outcast appearance, and the hard-core leather jacket, wrist strap and gloves push him further toward the dark side. He doesn't have pointed ears or teeth, because he hasn't yet matured into a full-fledged bloodsucker.

VAMPIRE BITES

IF YOU DO BECOME A VAMPIRE, THERE MAY BE A CURE. SOME SAY THAT IF THE MASTER, OR SIRE, VAMPIRE (THE VAMPIRE WHO TURNED YOU INTO ONE) IS KILLED, YOU WILL BE CURED OF VAMPIRISM. PIECE OF CAKE!

Interior of jacket visible

Shoulders puff out when sleeves are rolled up

Bottom of shirt covers belt line

Vampire Babe

This sexy modern vampire wears a form-fitting bodysuit that makes it easy to see her figure. You can use it as the basis for any beautiful female character. Give her extra-long legs and wide hips and shoulders. And since she's not baring her fangs, she needs to be drawn with blank eyes, to make it clear she's one of the undead.

Instead of having her stand with equal weight on both feet, which would look boringly symmetrical, shift her weight predominantly to her right foot. This causes the hips to angle to the right for a more dynamic pose.

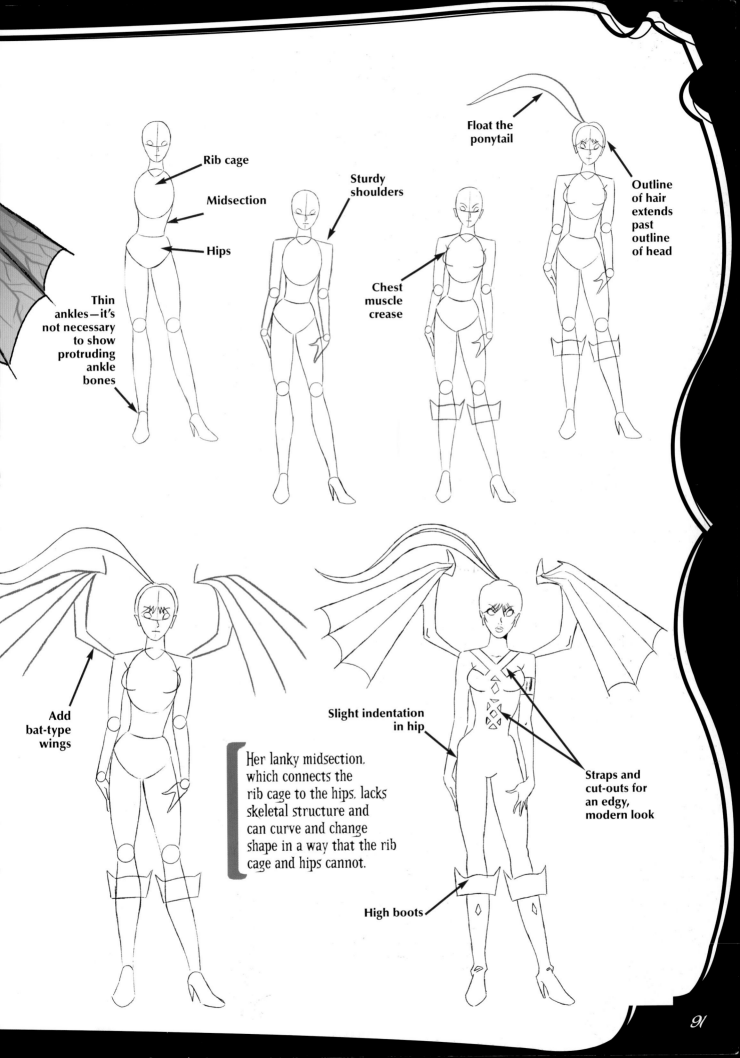

Rib cage

Midsection

Hips

Thin ankles—it's not necessary to show protruding ankle bones

Sturdy shoulders

Chest muscle crease

Float the ponytail

Outline of hair extends past outline of head

Add bat-type wings

Her lanky midsection, which connects the rib cage to the hips, lacks skeletal structure and can curve and change shape in a way that the rib cage and hips cannot.

Slight indentation in hip

Straps and cut-outs for an edgy, modern look

High boots

Lovely Mutant

This winged vampire is similar to the one we just drew, but her tail and furry clawed feet make her look even less human. Mutants like her can have scales, fur, markings or other exotic details. The wings can be colored brightly so that they "pop," or they can be muted, so that they don't overwhelm the character. When you've got a mutant, you don't have to restrict yourself to ordinary flesh colors. Remember, they ain't human! Here are just a few color choices for our mutant vampire gal.

Attack Mode

On a modern-style vampire, the wings usually come out only when he is ready to kill. In attack mode, all of his extreme features come into focus. His eyes, ears, mouth and hands can mutate to create a new, fierce look.

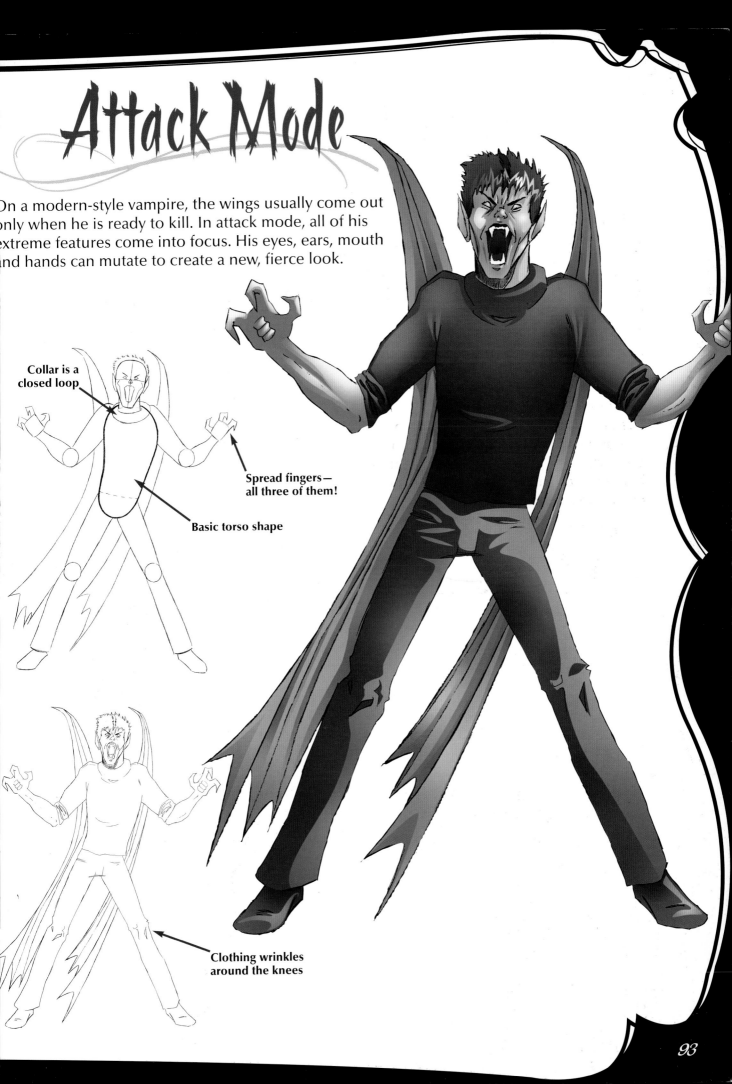

Collar is a closed loop

Spread fingers— all three of them!

Basic torso shape

Clothing wrinkles around the knees

Goth Femme Fatale

She's got a lot of sizzle with a healthy dose of style. Fashion-model tall, she doesn't need vampire teeth to look intimidating. Of course, she's also got to be beautiful: Dangerous and beautiful are a winning combination for a female vampire. The extra-long hair is typical vampire, and those trendy lenses give her a glamorous look.

Her fashion-model build features extremely long legs

Torso divides into two sections

Hair comes together in a point

Wide lapels emphasize strong shoulders

Interior of trench coat

Exterior of trench coat

The bare midriff is an attractive contemporary look. You want to lead your victim like a fly to honey.

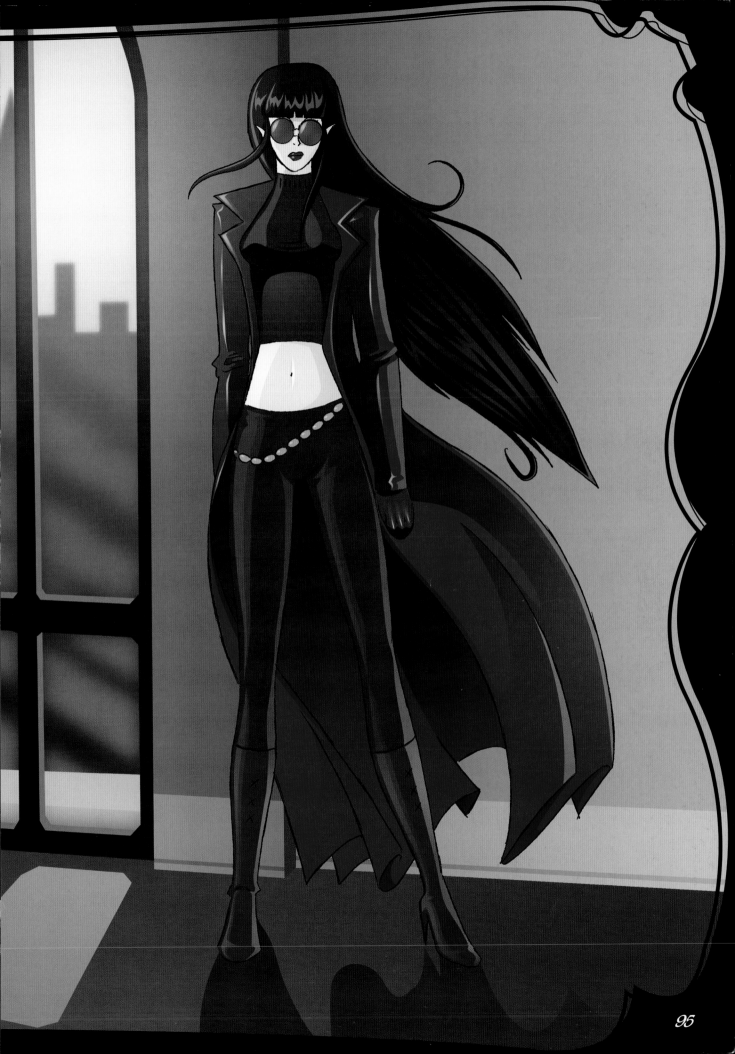

Sunlight & Vampires

Vampires are night-dwelling beasts that can't stand sunlight—literally. Sunlight will kill a vampire. There is but one hope for this afflicted, soulless creature: to get to the curtains and close them before he burns up in the light of day!

This drawing uses a lot of perspective to give the impression of a figure receding toward the window.

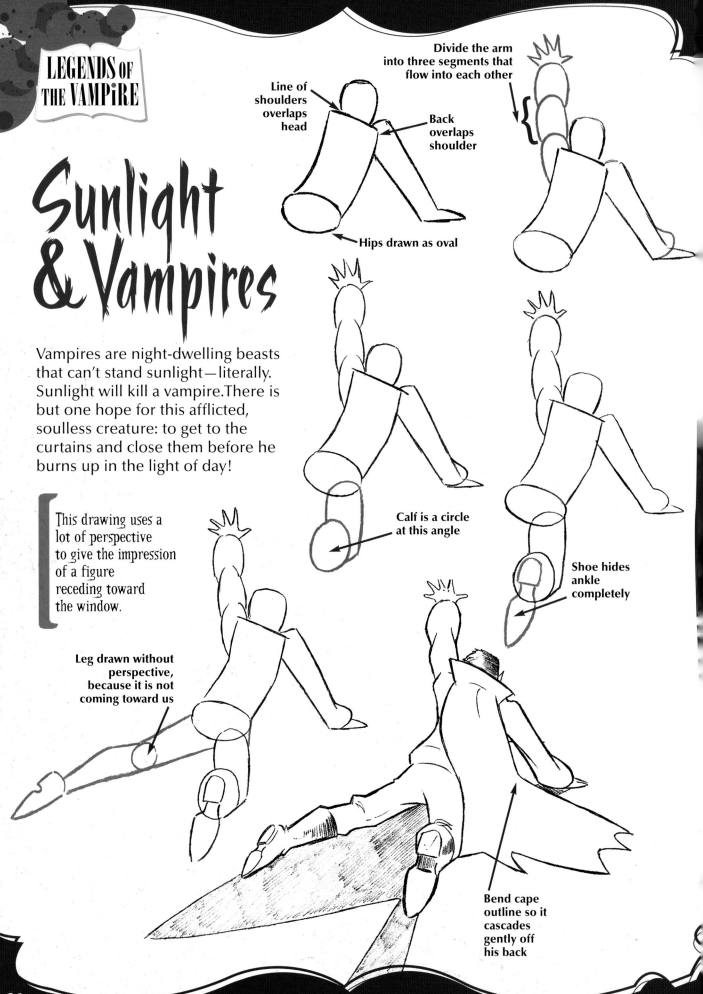

Line of shoulders overlaps head

Back overlaps shoulder

Divide the arm into three segments that flow into each other

Hips drawn as oval

Calf is a circle at this angle

Shoe hides ankle completely

Leg drawn without perspective, because it is not coming toward us

Bend cape outline so it cascades gently off his back

Note the long shadow, which occurs because the sun is low on the horizon. It's important to show the sun as it's coming up, as if the vampire has lingered too long into the night. If the sun were high in the sky, you would wonder how the vampire had managed to stay alive so long into the day.

A TASTE FOR Blood

In this chapter, we'll focus on the obsession of every vampire: human blood. Vampires don't just require blood to live; they have a psychological need for it as well. These dark creatures of the night exalt in their feeding frenzy. There is a euphoria that sets in when they feast. It's one of the most important moments in vampire stories, and is often highlighted in films and graphic novels.

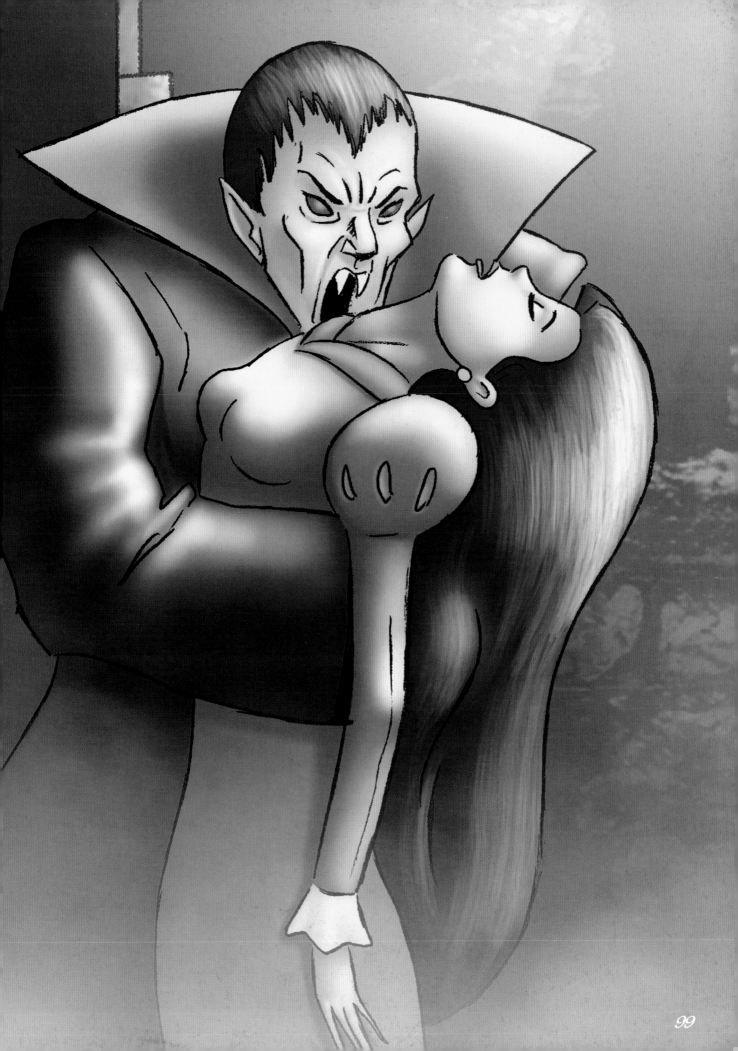

The Bite

The vampire hunches over as if enveloping his victim

When a vampire attacks his victim, he overcomes her, rendering her helpless. He must, therefore, support her weight, or she will fall into a heap. Drawing this pose requires a few basic techniques or it may look awkward. Let's take a look at how to construct this all-important moment.

Victim is totally relaxed

Showing the teeth is a must

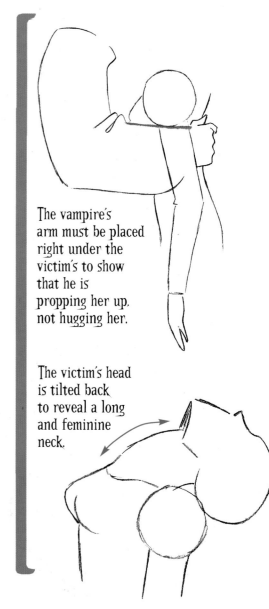

The vampire's arm must be placed right under the victim's to show that he is propping her up, not hugging her.

The victim's head is tilted back to reveal a long and feminine neck.

Going for the Jugular

The vampire doesn't bite just any part of the body. He goes right for the jugular vein in the neck—the main vein through which copious amounts of blood flow. The jugular appears on each side of the neck and travels from the collarbone all the way up into the base of the jaw. Tilting the head back exposes the jugular vein at its full length, which is why vampires like to position their victims in this manner.

VAMPIRE BITES

VAMPIRES HAVE BEEN KNOWN TO FEED ON CATTLE AND OTHER ANIMALS WHEN HUMANS ARE IN SHORT SUPPLY, BUT THIS SUBSTITUTE ISN'T ADEQUATE TO FULFILL THEIR LONG-TERM PHYSICAL NEEDS AND THEY MUST EVENTUALLY SEEK OUT THEIR PRIMARY FOOD SOURCE: US!

Good-night Kiss

Turnabout is fair play, so here we have a gal biting a guy. But unlike the scene in which the male vampire bites the girl, the female vampire cannot bite down on her victim, because she's shorter than he is. Again, the victim doesn't resist; he's already under her spell. We can tell that by the fact that she has gently placed her hands on his shoulders, rather than struggling to hold him still.

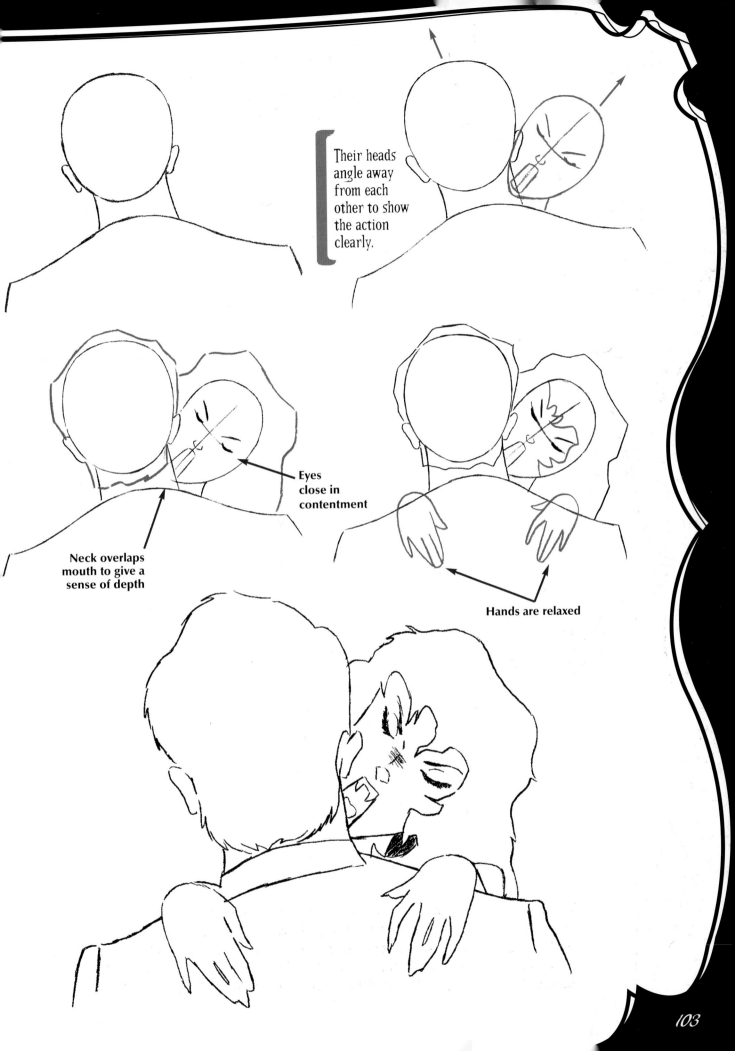

Their heads angle away from each other to show the action clearly.

Eyes close in contentment

Neck overlaps mouth to give a sense of depth

Hands are relaxed

Finger-Licking Good

Fingers straight and spread apart

When you illustrate a story, look for "moments"—interesting bits—you can depict. There are many of these moments in the vampire genre besides the biting of people's necks. There's the sublime moment afterwards when the vampire is savoring the last bits of her meal, which is equally dramatic.

Wide hips follow a narrow waist

Center line, which flows along torso, is not a straight line

Closed eyes give her a look of enjoyment

Bent wrist

Allow the blood to drip gradually down the fingers. And you don't have to overdo it: A small amount of blood is sufficiently grisly!

"This low-carb diet isn't so bad."

After the Feast

The vampire is in a state of quiet bliss, because his terrible hunger is satisfied— for now. Unfortunately for humans, it's a neverending cycle, as the hunger will strike again—and soon. To convey the look of satiation close his eyes halfway and let his mouth open a touch. A slight smile creeps across his lips. Mmm, that was good.

"Ahh, full at last."

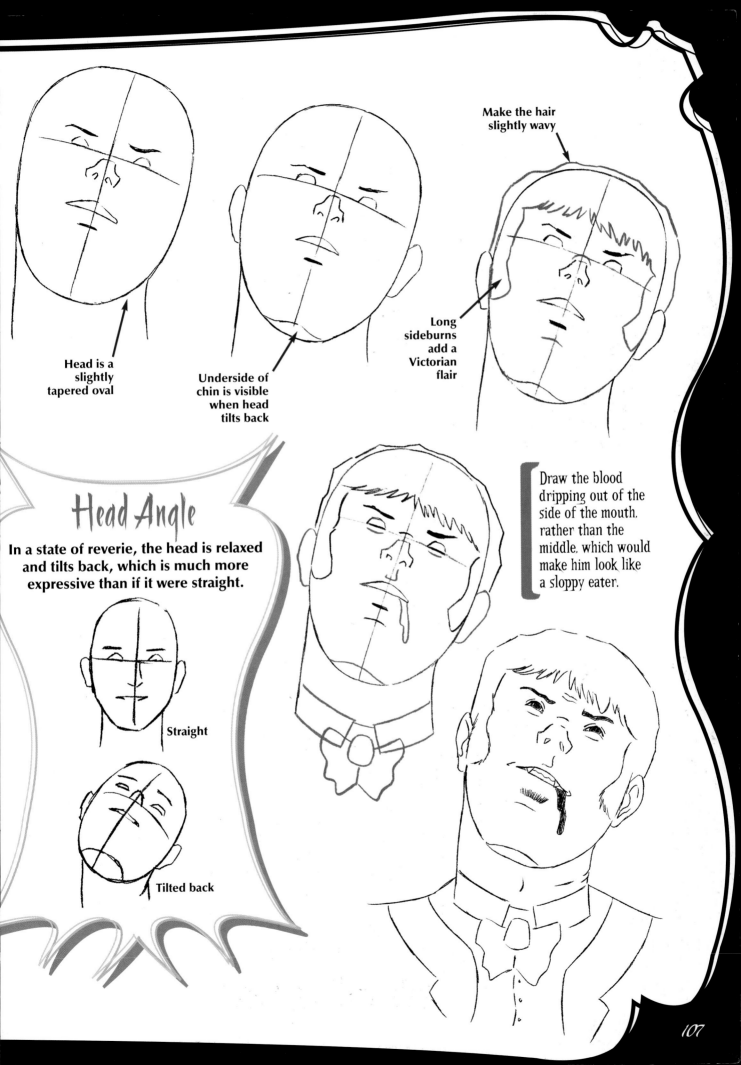

Head is a slightly tapered oval

Underside of chin is visible when head tilts back

Make the hair slightly wavy

Long sideburns add a Victorian flair

Head Angle

In a state of reverie, the head is relaxed and tilts back, which is much more expressive than if it were straight.

Straight

Tilted back

Draw the blood dripping out of the side of the mouth, rather than the middle, which would make him look like a sloppy eater.

Vampire's Remorse

Some vampires do not like what they must do to live. Depicting a vampire's regret adds depth to the character. This reflective expression is created by drawing the eyes cast down and welling up with tears.

Bring the eyebrows slightly together and down. Not too much—we don't want him to appear angry, only troubled.

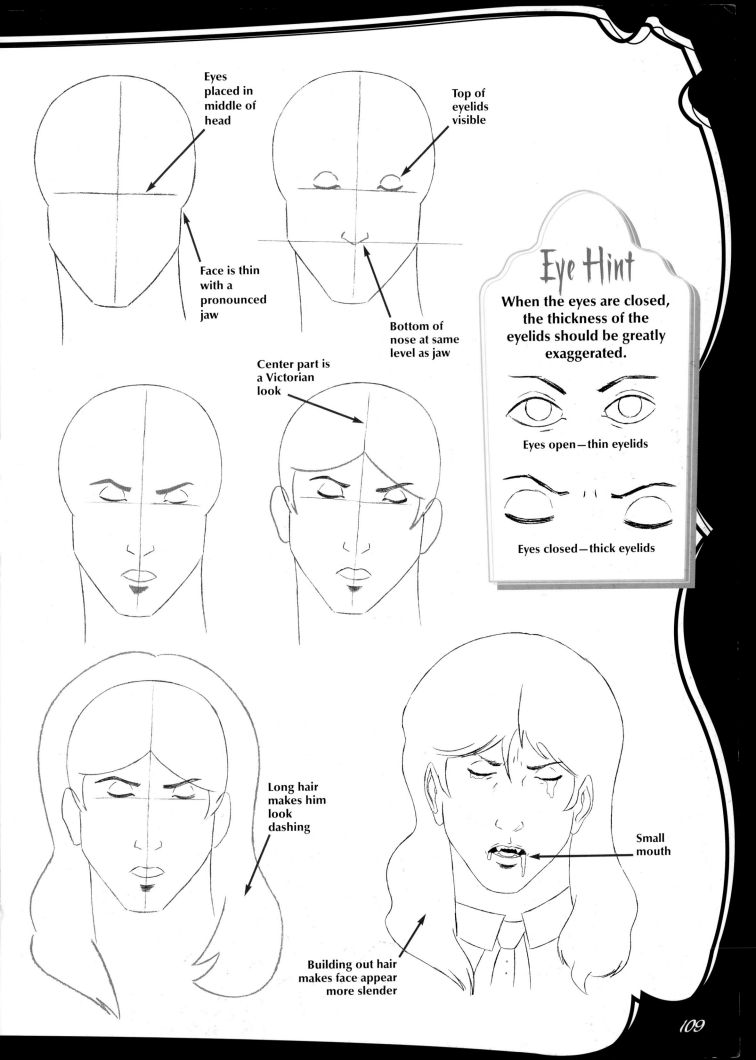

Eyes placed in middle of head

Face is thin with a pronounced jaw

Top of eyelids visible

Bottom of nose at same level as jaw

Center part is a Victorian look

Eye Hint

When the eyes are closed, the thickness of the eyelids should be greatly exaggerated.

Eyes open—thin eyelids

Eyes closed—thick eyelids

Long hair makes him look dashing

Building out hair makes face appear more slender

Small mouth

Castle of the Dark Count

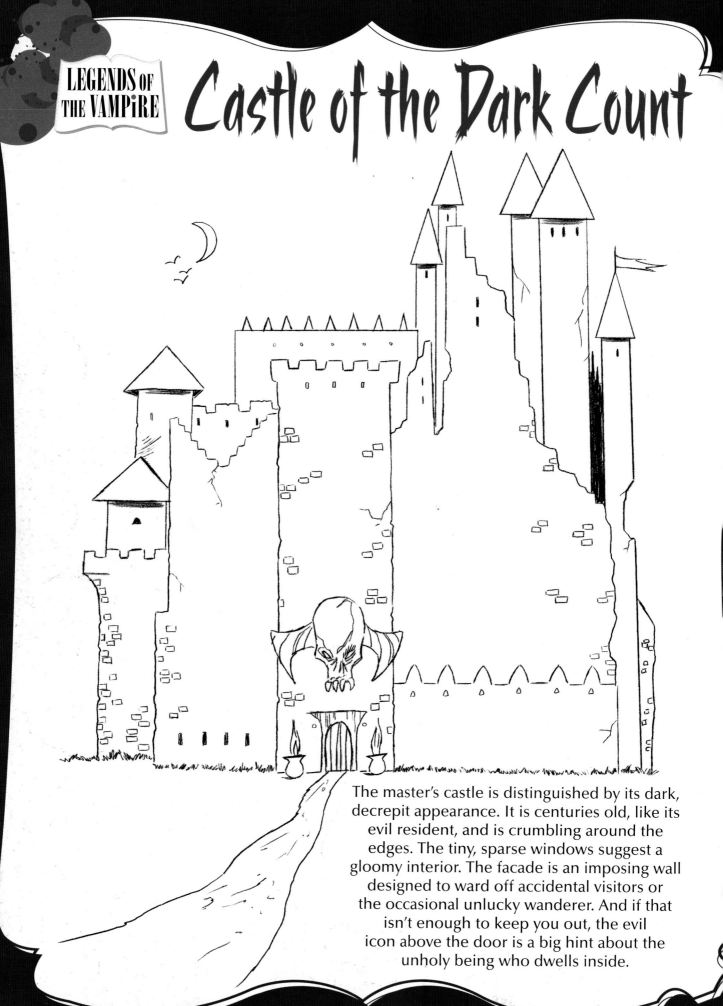

The master's castle is distinguished by its dark, decrepit appearance. It is centuries old, like its evil resident, and is crumbling around the edges. The tiny, sparse windows suggest a gloomy interior. The facade is an imposing wall designed to ward off accidental visitors or the occasional unlucky wanderer. And if that isn't enough to keep you out, the evil icon above the door is a big hint about the unholy being who dwells inside.

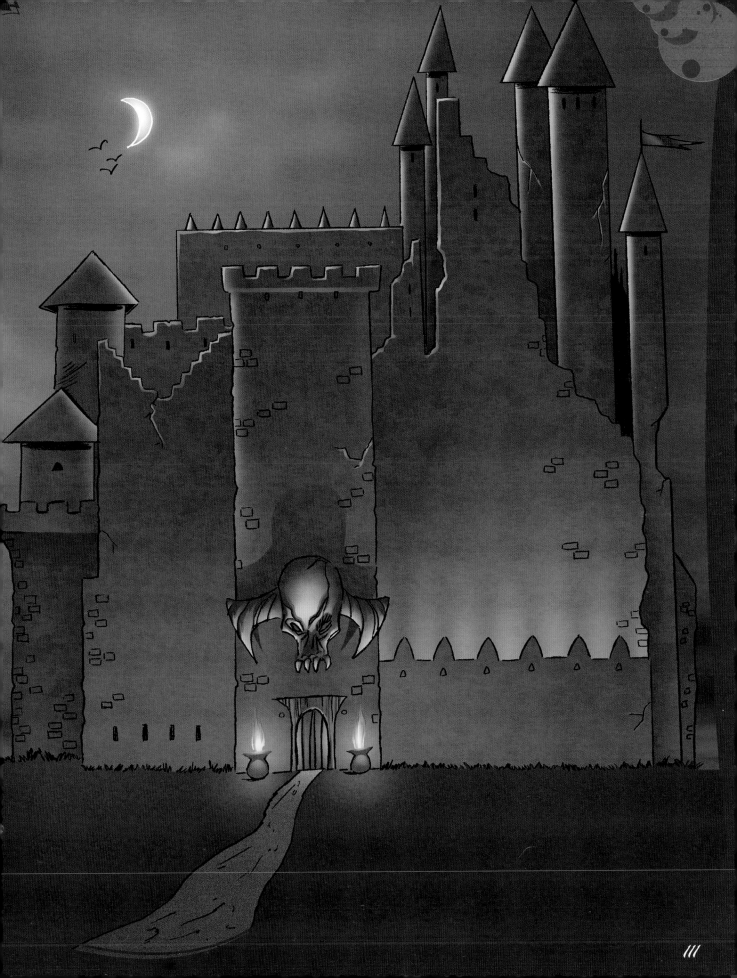

Vampire Slayers

There exist a few specialists whose lifelong work is the disposal of the evil bloodsuckers. These are the vampire hunters. Some are motivated by vengeance, others by money. It's good work, if you can get it, but the career of the average vampire hunter is very, very short. Before one kills vampires, one has to find them. So let's light our torches and journey into the deepest parts of the woods, at night, when the vampires are the most active—and dangerous!

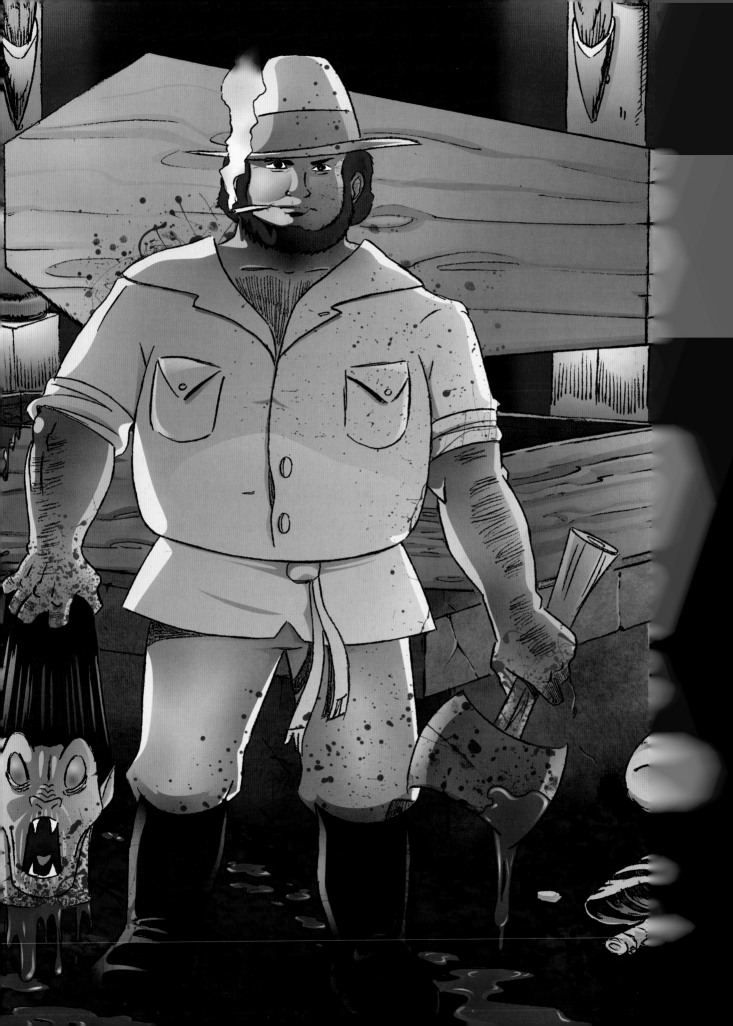

Stake for Hire

Killing the undead isn't for sissies. It's one of the roughest jobs around. And it takes a special type of personality: sort of a cross between a hard-core biker and an ax murderer. He's the type of guy who can enter a village, turn a half dozen vampires into shish kebabs and leave without even waiting to be thanked. Just knowing that he put those fanged creeps back to sleep is all the thanks he needs.

Add lots of folds and wrinkles to his pants and leather jacket and give him tough lace-up boots. His eye patch and scars show that he's a veteran of many fights.

This fearless hunter's wide stance screams "No retreat!"

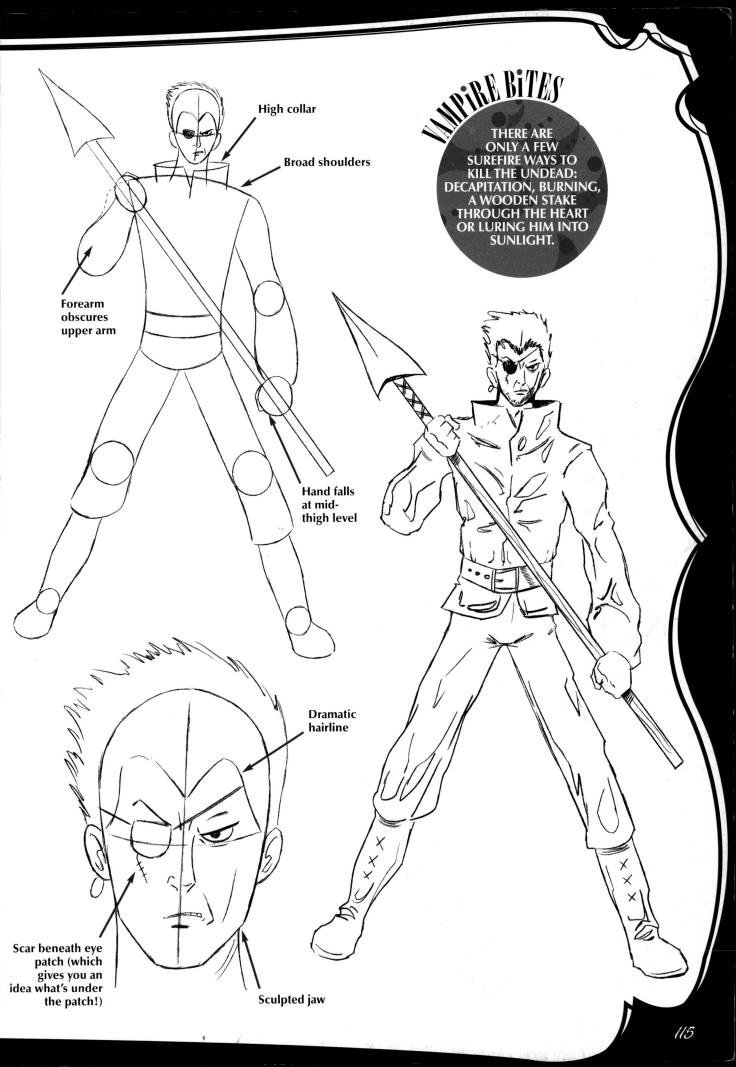

High collar

Broad shoulders

Forearm obscures upper arm

Hand falls at mid-thigh level

Dramatic hairline

Scar beneath eye patch (which gives you an idea what's under the patch!)

Sculpted jaw

115

On the Trail

Drawing the slayer from this angle increases the drama. Perhaps his quarry is watching him—from above! This heavily angled shot compresses the image, almost like a film shot. It's a slightly tricky pose, but taking it step by step will ensure success.

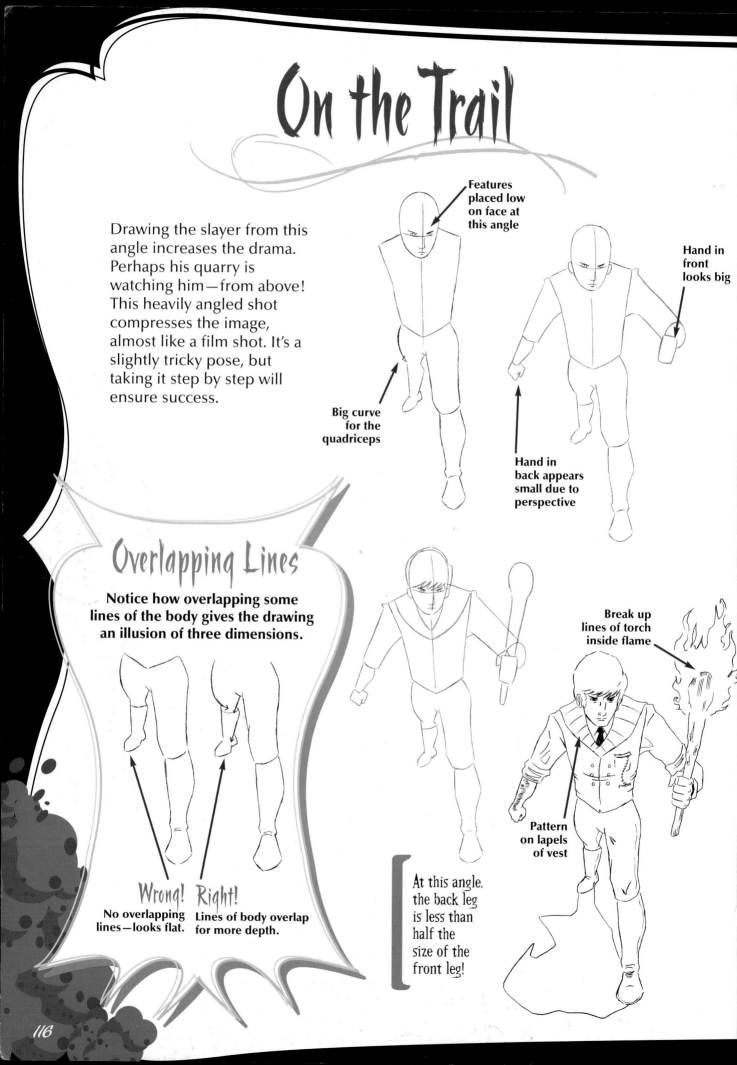

Features placed low on face at this angle

Hand in front looks big

Big curve for the quadriceps

Hand in back appears small due to perspective

Overlapping Lines

Notice how overlapping some lines of the body gives the drawing an illusion of three dimensions.

Wrong!
No overlapping lines—looks flat.

Right!
Lines of body overlap for more depth.

Break up lines of torch inside flame

Pattern on lapels of vest

At this angle, the back leg is less than half the size of the front leg!

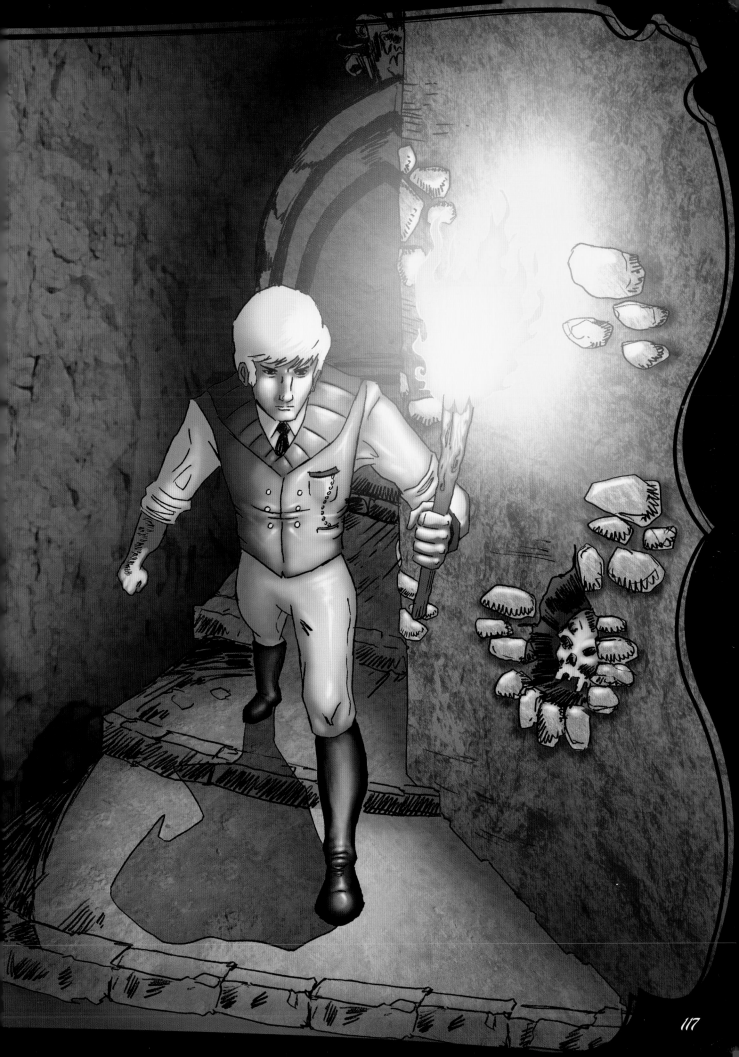

A Cure for Vampirism

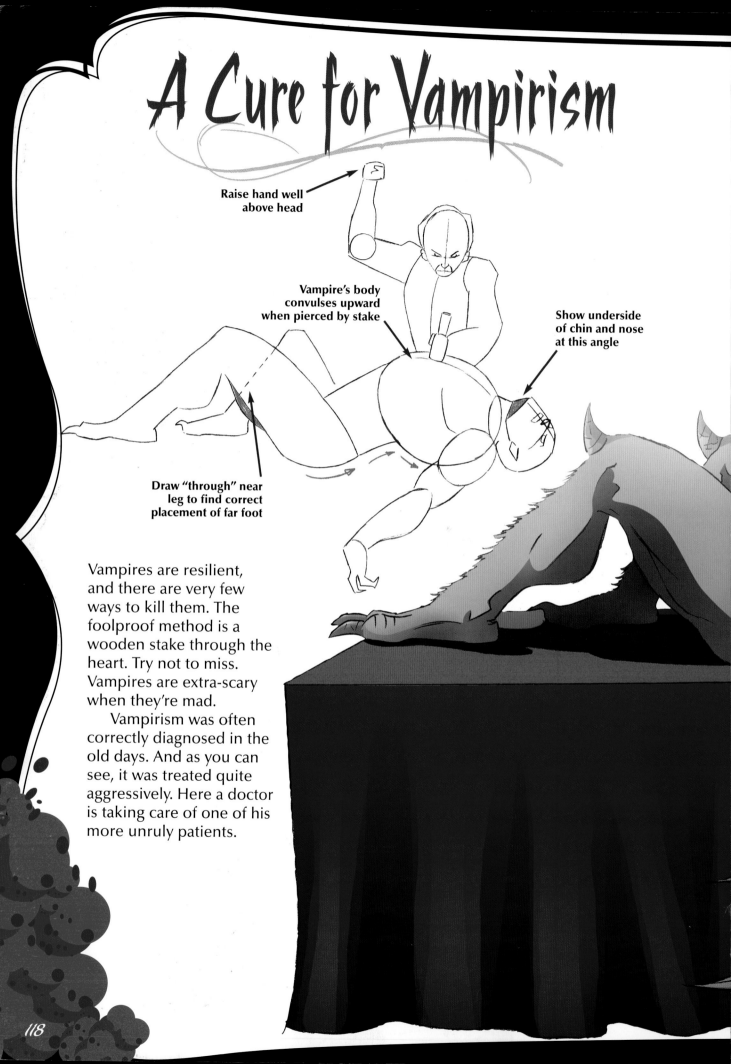

Raise hand well above head

Vampire's body convulses upward when pierced by stake

Show underside of chin and nose at this angle

Draw "through" near leg to find correct placement of far foot

Vampires are resilient, and there are very few ways to kill them. The foolproof method is a wooden stake through the heart. Try not to miss. Vampires are extra-scary when they're mad.

Vampirism was often correctly diagnosed in the old days. And as you can see, it was treated quite aggressively. Here a doctor is taking care of one of his more unruly patients.

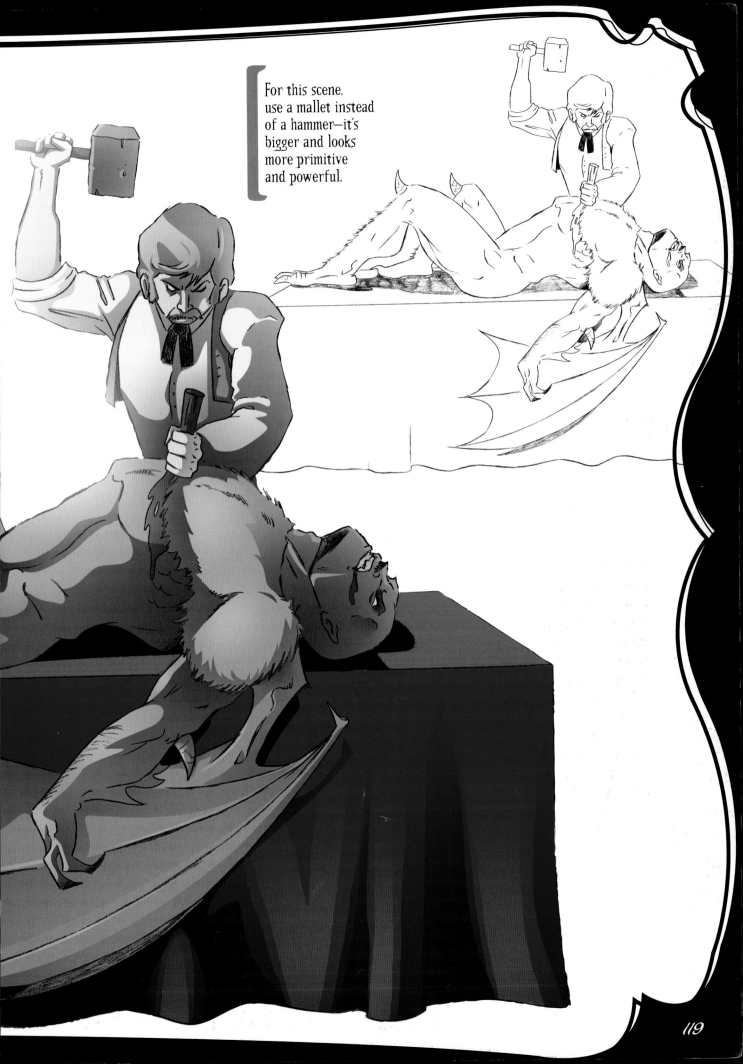

For this scene, use a mallet instead of a hammer—it's bigger and looks more primitive and powerful.

Big jowls

Thick forearms

Belly hangs over belt, obscuring it

Got Him!

Another method of killing vampires is decapitation, which was widely used a century ago in the old country. Even the undead can't regenerate a new head. Vampire hunting is a messy business. Slayers try not to get any of the blood on themselves, as vampirism can be spread this way, too. When drawing this slayer, make the head small to highlight his sizable girth.

Lapels are stretched wide

Tilt brim of hat

Hair pulled straight by weight of head

Some hunters collect trophies from their kills. Hey, everyone needs a hobby!

Round and (Not) Round

When drawing the center line on heavy characters, bend it to one side or the other to make the body appear round. A straight center line flattens out the body.

Right! Body looks round.

Wrong! Body looks flat.

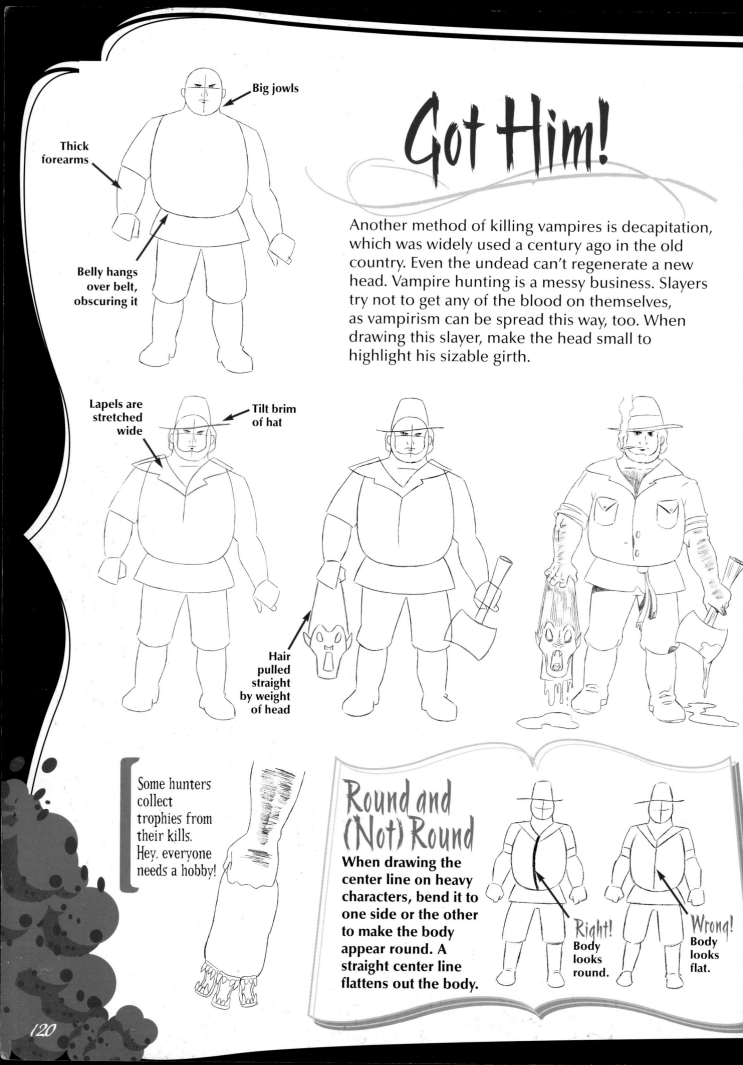

For an especially gruesome scene, draw the decapitated vampire head with its mouth wide open in a shocked expression.

The Huntress

She's not going to let the boys have all the fun. Notice how casual her pose is, like she's been chopping off vampire heads her whole life. She is just so confident. And that ax is so big. I went for a fantasy-style vampire huntress, which makes her look a little primitive—and very attractive.

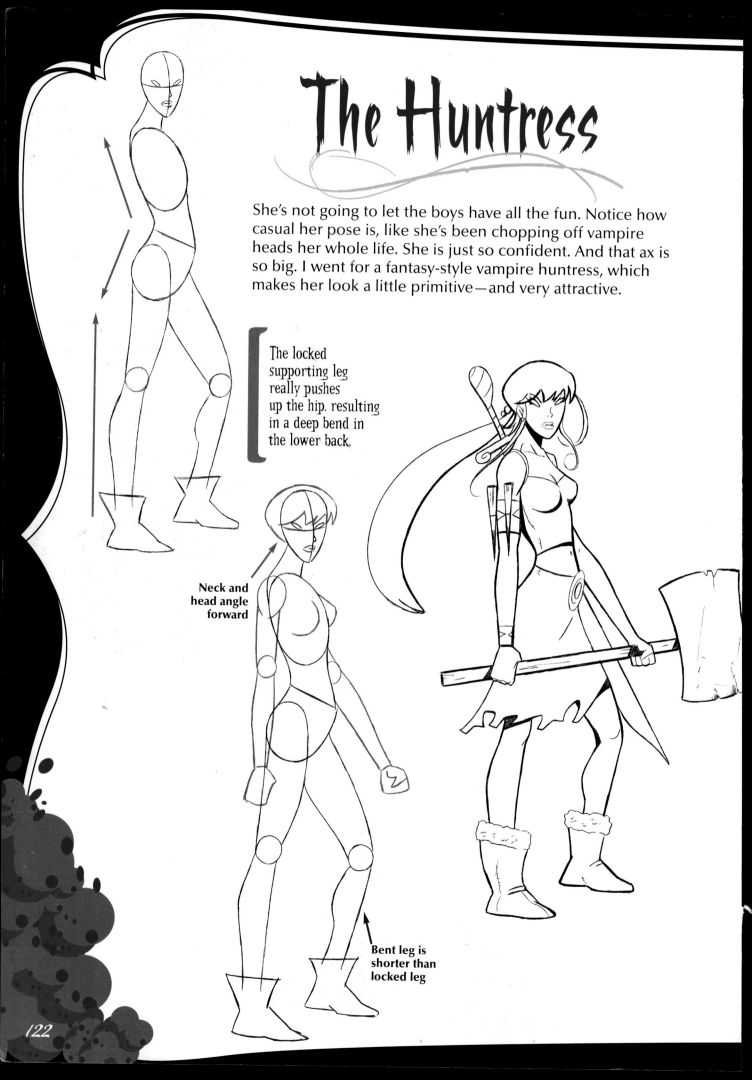

The locked supporting leg really pushes up the hip, resulting in a deep bend in the lower back.

Neck and head angle forward

Bent leg is shorter than locked leg

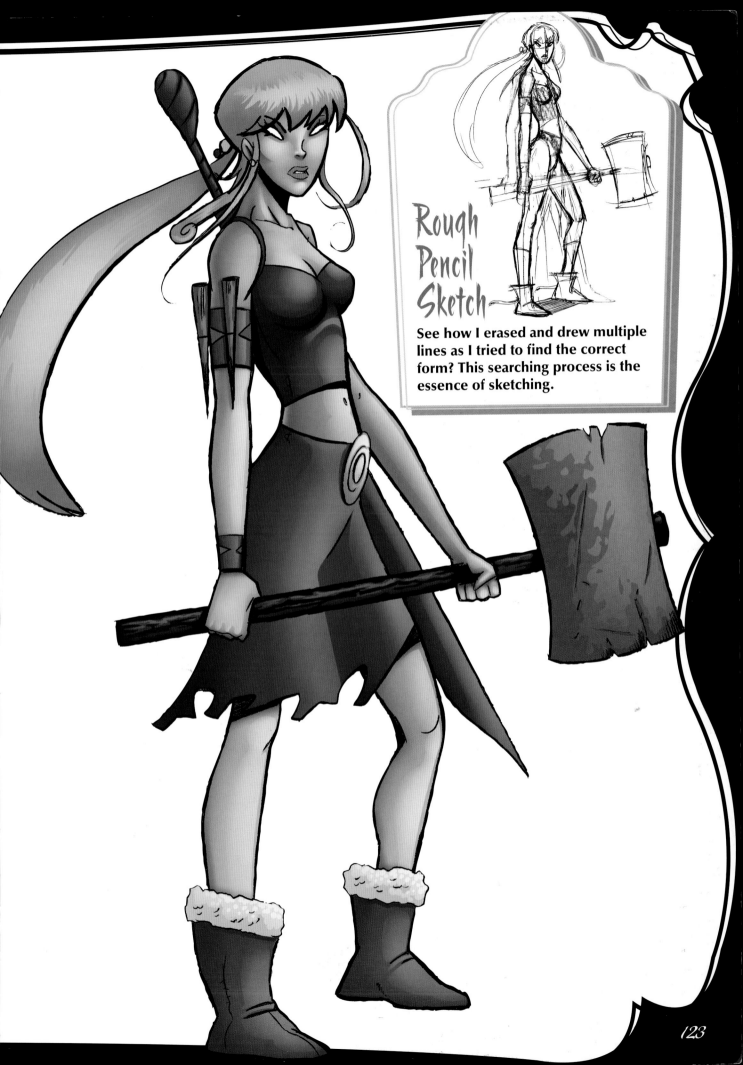

Rough Pencil Sketch

See how I erased and drew multiple lines as I tried to find the correct form? This searching process is the essence of sketching.

Out for Vengeance

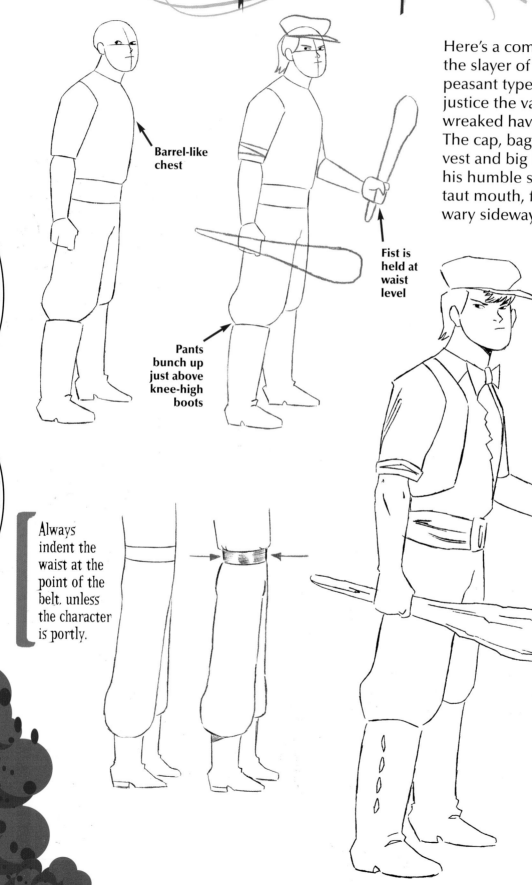

Barrel-like chest

Fist is held at waist level

Pants bunch up just above knee-high boots

Here's a common variation on the slayer of vampires. He's a peasant type seeking to bring to justice the vampire who wreaked havoc on his village. The cap, baggy pants, opened vest and big belt buckle indicate his humble status. Notice his taut mouth, flared nostrils and wary sideways glance.

Always indent the waist at the point of the belt, unless the character is portly.

Flow from one arm into the other creates a pleasing action line

Draw a sweeping line for the hem

Trench Coat Action

A trench coat can be as expressive as a cape, and just as flamboyant. Like a cape, it catches the air and twists and turns to create folds. And it's always most dramatic when you show the reader the interior and the exterior of the trench coat, as in this example.

Cowardly Hunter

Have pity on this poor vampire hunter. He seems to have lost his nerve at the last moment, when he needs it most. I don't expect things will work out very well for him.

Flamethrowing a Vampire

This cool scene features a modern vampire and vampire hunter. The hunter will be using a flamethrower—the contemporary equivalent of a spike and mallet—on the night beast. There's a lot of action going on in this scene. It's a good idea to start by drawing the character who is initiating the action (the hunter). That way, you have something to react to when drawing the second character.

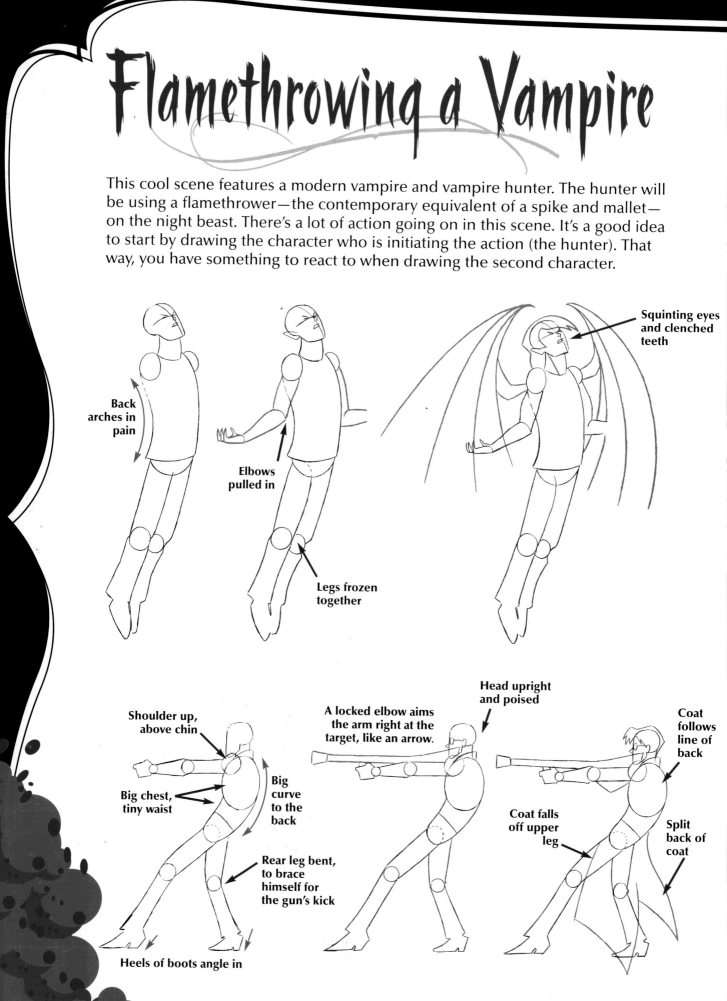

Back arches in pain

Elbows pulled in

Legs frozen together

Squinting eyes and clenched teeth

Shoulder up, above chin

Big chest, tiny waist

Big curve to the back

Rear leg bent, to brace himself for the gun's kick

Heels of boots angle in

A locked elbow aims the arm right at the target, like an arrow.

Head upright and poised

Coat falls off upper leg

Coat follows line of back

Split back of coat

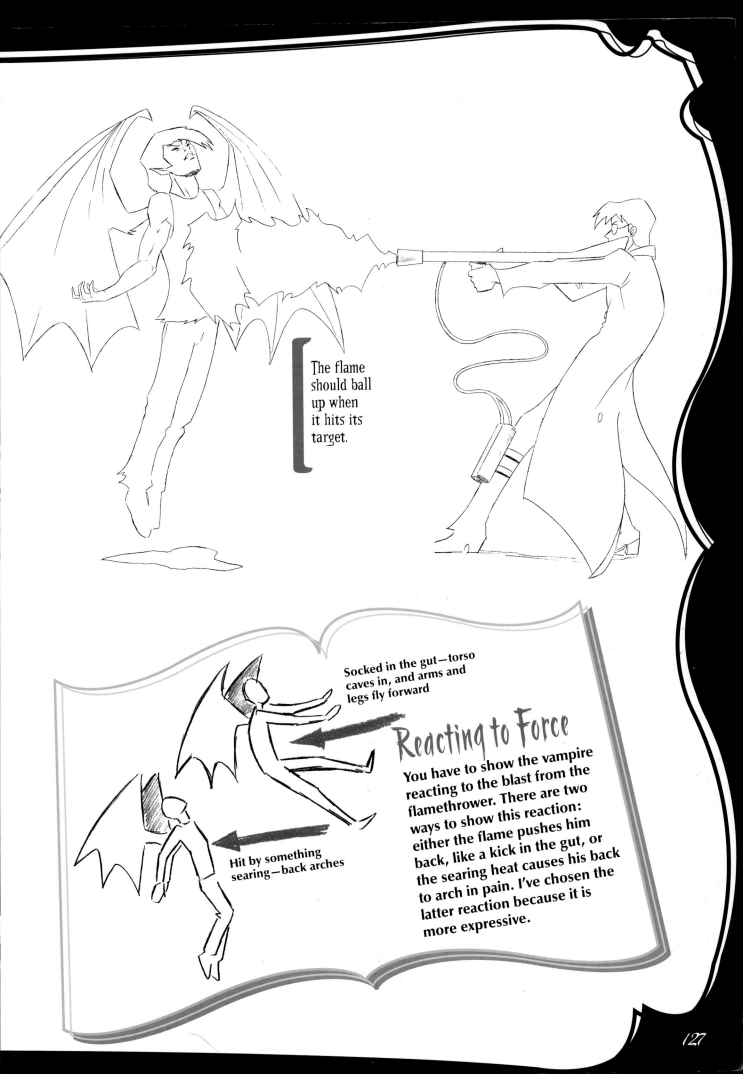

The flame
should ball
up when
it hits its
target.

Socked in the gut—torso
caves in, and arms and
legs fly forward

Reacting to Force

You have to show the vampire reacting to the blast from the flamethrower. There are two ways to show this reaction: either the flame pushes him back, like a kick in the gut, or the searing heat causes his back to arch in pain. I've chosen the latter reaction because it is more expressive.

Hit by something
searing—back arches

Scene Staging

Remember, characters fight at close range, but there has to be some distance between them when weapons are used. Place them too far apart, however, and the impact will be lost. You want to be able to take in the entire image in a single glance, without having to scan from one character to the other.

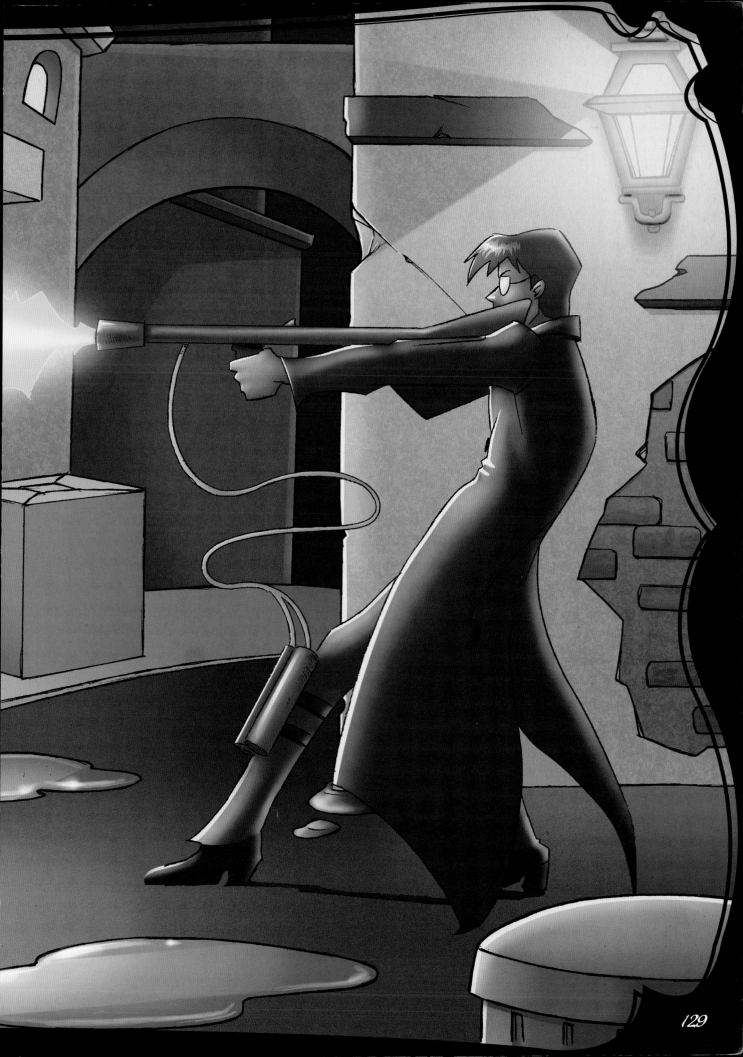

Defenses Against Vampires

Vampires are powerful, but they are not all-powerful. They have weaknesses, which can be exploited. The following items will help keep you from becoming an involuntary blood donor…for the moment. Although they will not kill the vampire, they will cause great pain, giving you much-needed time to flee.

ROSARY
A string of beads used for prayer, a rosary works just like a cross to keep vampires at bay.

WILD ROSE BRANCH
Some legends claim that placing a rose branch in a grave will prevent the corpse from becoming a vampire.

HOLY WATER
Holy water is plain water that has been blessed by a priest. Splattered on vampires, it burns their skin.

SIGN OF THE CROSS
A crucifix is a classic vampire repellent, but holding two sticks together in the shape of a cross works in a pinch!

STRING OF GARLIC
Wearing garlic around your neck won't get you any dates, but it will make vampires think twice about attacking you.

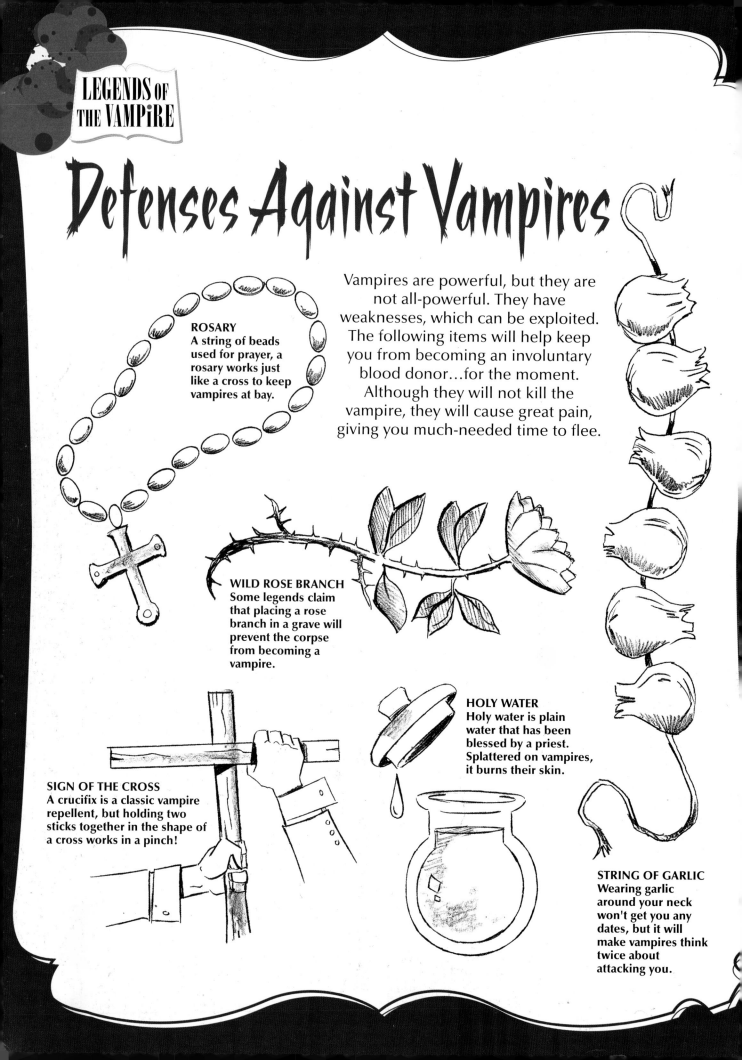

"Is this
any way
to treat a
guest?"

Beasts of the Vampire World

n vampire stories, other creatures, such as werewolves, zombies, gargoyle-like creatures and other staples of the horror genre, often act as supporting characters. These strange beasts, powerful and more animal-like than vampires, kill humans for sport and sometimes food. As if vampires weren't enough to worry about. Oh yes, it's a dangerous world out there.

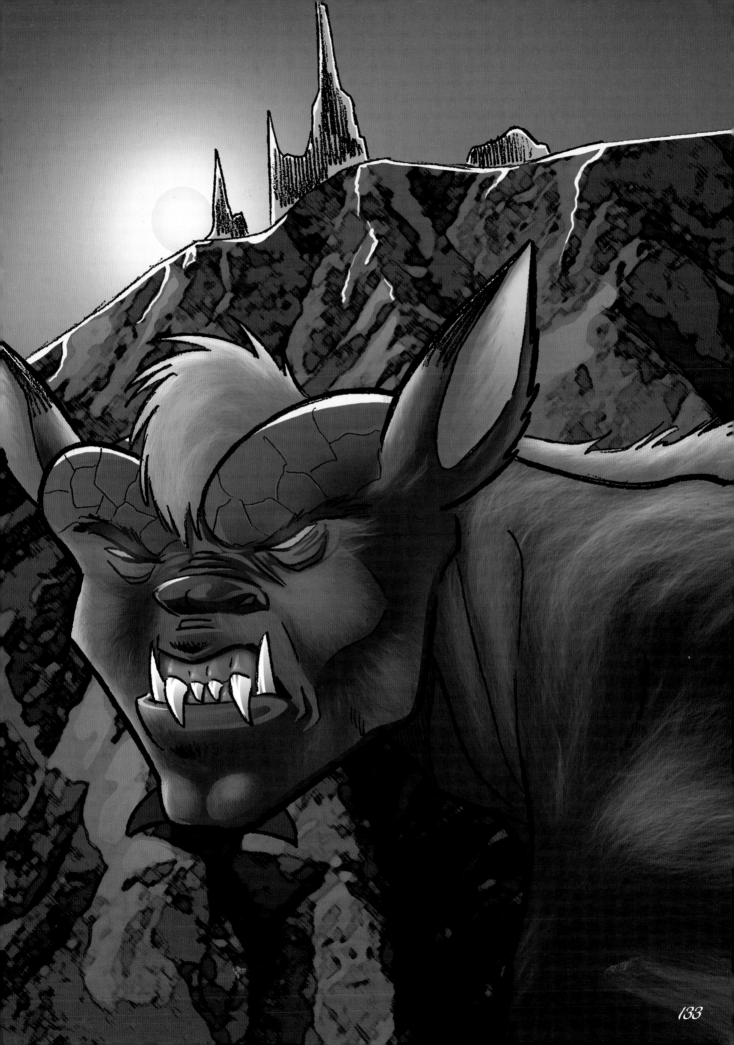

The Werewolf

While werewolves have often been portrayed as humans with furry faces and hands, the modern werewolf retains more wolf-like anatomy. Draw him as a towering figure, with hunched shoulders. The legs are jointed like a wolf's, but not a lot— just enough to give the indication that he's part animal. His hems have crept up on him, because he increased dramatically in size when he transformed.

VAMPIRE BITES

IT'S NO SECRET THAT VAMPIRES CAN TURN INTO BATS, BUT SOME OF THESE SNEAKY SHAPE-SHIFTERS HAVE ALSO BEEN KNOWN TO TRANSFORM THEMSELVES INTO WOLVES.

No neck— head sinks deeply into shoulder area

Huge shoulders

Small waistline

Ankle joint protrudes

Notice the simple backward bend each leg makes. It's just a small amount, to suggest a canine structure.

Zombies

Zombies are kissing cousins of the vampire, as they're both undead. Vampires, however, can double as humans, while a zombie isn't going to be able pass for anything other than a zombie, because he's still wearing the decaying, disgusting clothes that he died in.

DRAWING THE HEAD

Zombie heads are wonderfully gross. Since zombies have been in the ground for a while, they have, er, ripened a bit. As a general rule, the longer you stay in the ground, the less handsome you become.

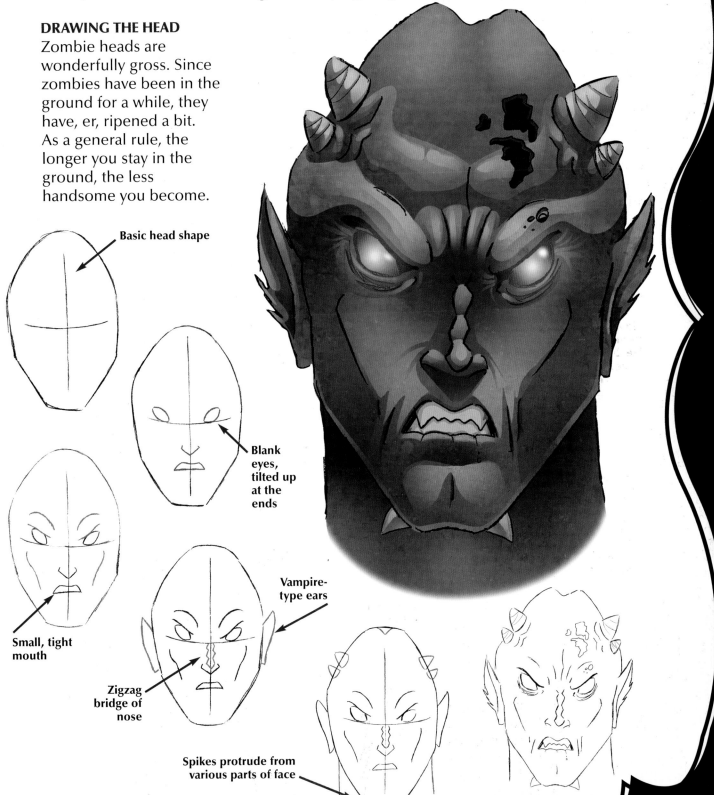

Basic head shape

Blank eyes, tilted up at the ends

Small, tight mouth

Zigzag bridge of nose

Vampire-type ears

Spikes protrude from various parts of face

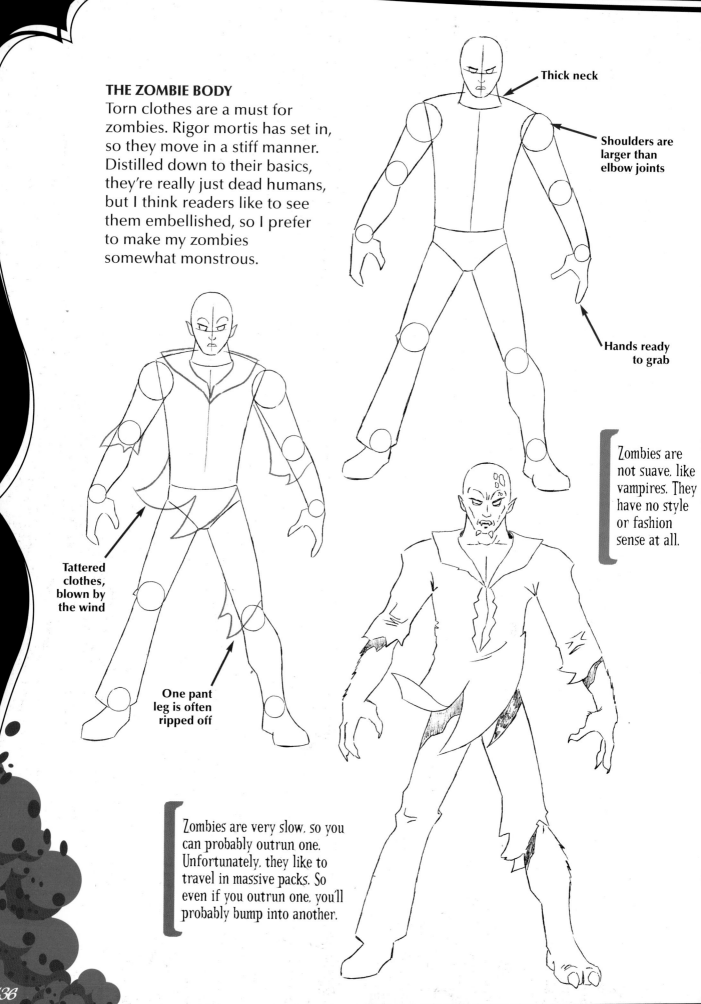

THE ZOMBIE BODY

Torn clothes are a must for zombies. Rigor mortis has set in, so they move in a stiff manner. Distilled down to their basics, they're really just dead humans, but I think readers like to see them embellished, so I prefer to make my zombies somewhat monstrous.

Thick neck

Shoulders are larger than elbow joints

Hands ready to grab

Tattered clothes, blown by the wind

One pant leg is often ripped off

Zombies are not suave, like vampires. They have no style or fashion sense at all.

Zombies are very slow, so you can probably outrun one. Unfortunately, they like to travel in massive packs. So even if you outrun one, you'll probably bump into another.

"I've been dying to meet you."

Big-Browed Beast

With a scruffy mane and fur covering its body, this ugly monster would never be mistaken for a vampire. Especially vicious, he has a huge set of killer teeth. His gums show when he growls, just like on a wolf. The forehead is quite low—in fact he has almost no forehead at all, outside of that huge brow.

The Thing About Large Brows

Large, I mean really large, brows give characters the look of mutants. Look at the difference it makes when you just add super-exaggerated brows to a human.

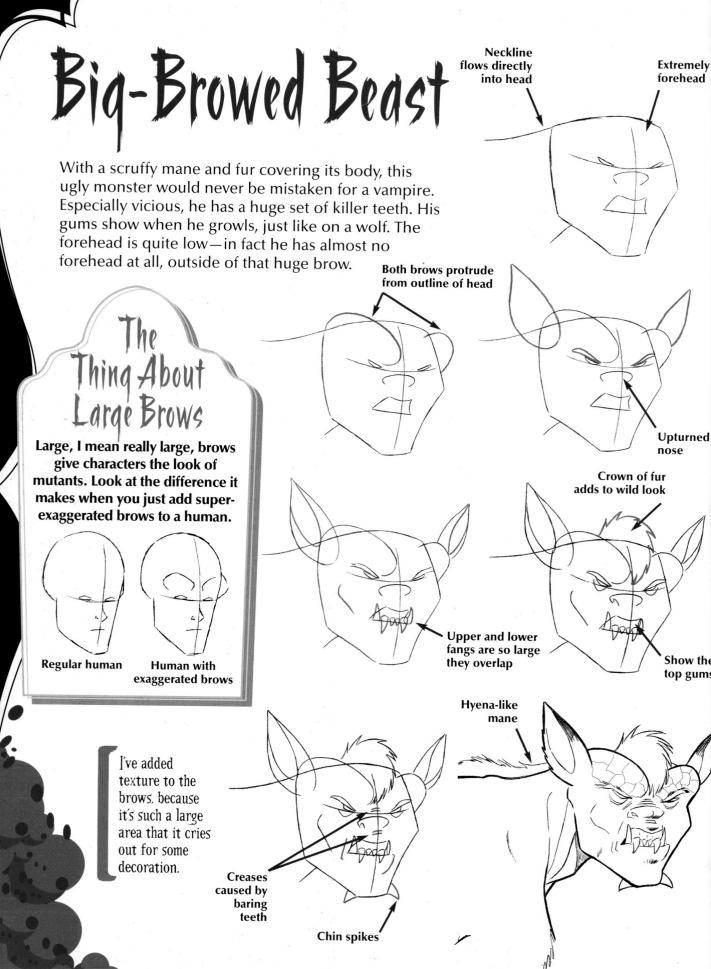

Regular human

Human with exaggerated brows

Neckline flows directly into head

Extremely forehead

Both brows protrude from outline of head

Upturned nose

Crown of fur adds to wild look

Upper and lower fangs are so large they overlap

Show the top gums

Hyena-like mane

I've added texture to the brows, because it's such a large area that it cries out for some decoration.

Creases caused by baring teeth

Chin spikes

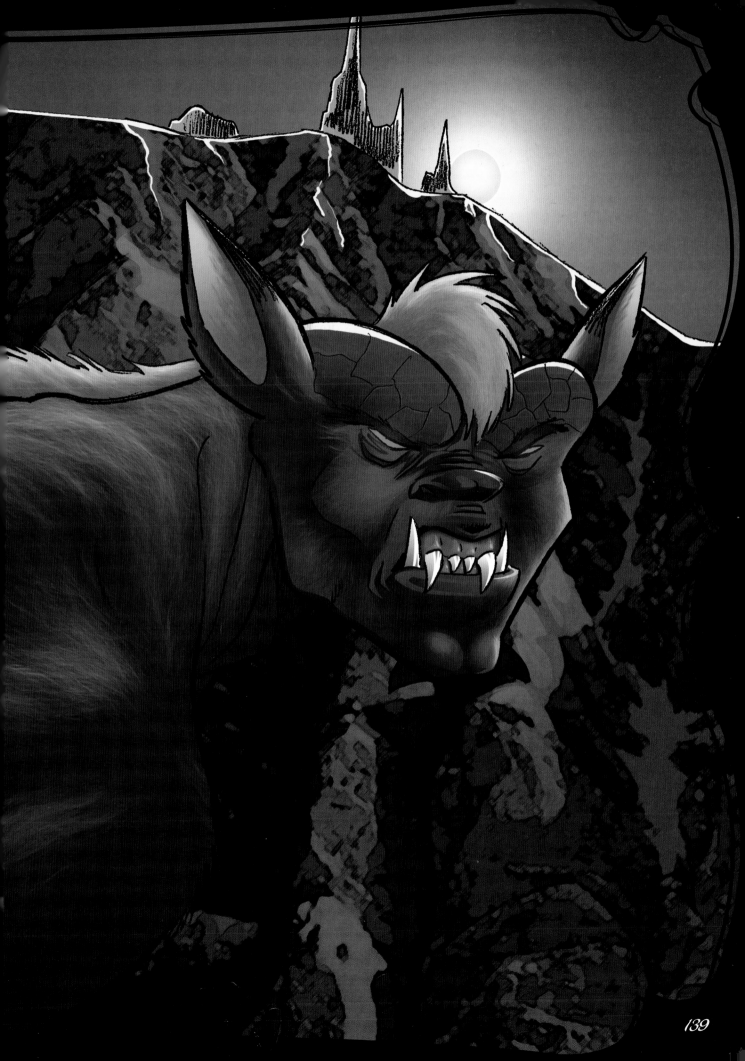

Gargoyle-Human Hybrid

This fearsome fellow crouches on the edge of a rooftop, ready to swoop down on unsuspecting passersby. His powerful presence is amplified by his stance: coiled and ready to pounce. He has beastly bottom fangs, instead of upper canines, as an evil variation. And no, you can't take him home; he's not a pet.

Large rib cage and tiny waist, for a powerful look

In this alternative head position, the chin is tucked in, eliminating the neck.

Large shoulders

Tail is flexed

Hind leg's joint configuration is the same as a lion's

Two "fingers" on each hand

Super-Massive Gargoyle

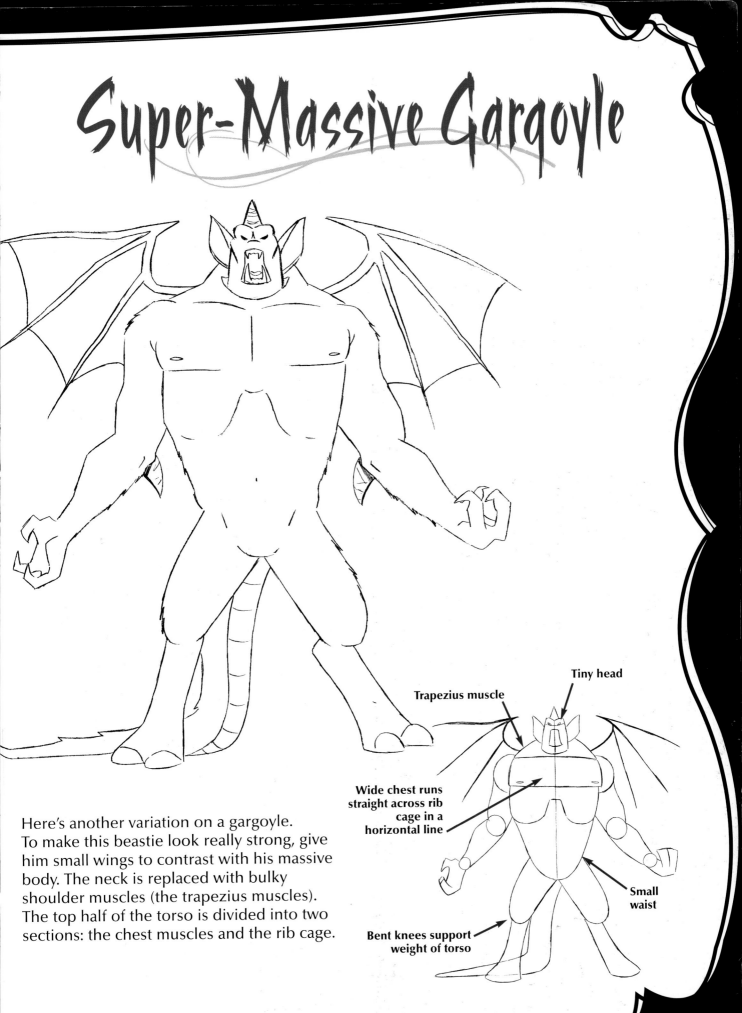

Tiny head

Trapezius muscle

Wide chest runs straight across rib cage in a horizontal line

Small waist

Bent knees support weight of torso

Here's another variation on a gargoyle. To make this beastie look really strong, give him small wings to contrast with his massive body. The neck is replaced with bulky shoulder muscles (the trapezius muscles). The top half of the torso is divided into two sections: the chest muscles and the rib cage.

Creepy Crawler

He has a delightfully wicked smile, with menacing eyes.

Hunched over and scampering across the ground like a scorpion is this most creepy of beasts. He exudes evil as he drools with anticipation at a good catch. When I draw a character that is decidedly non-human, I like to give him an irregular number of digits. This guy has only four fingers on each hand and two toes on each foot.

Get a Leg Up

Here's a hint for making the beast's leg look wild and mean.

Wrong! Long portion of leg flat on ground.

Right! Long portion of leg upright.

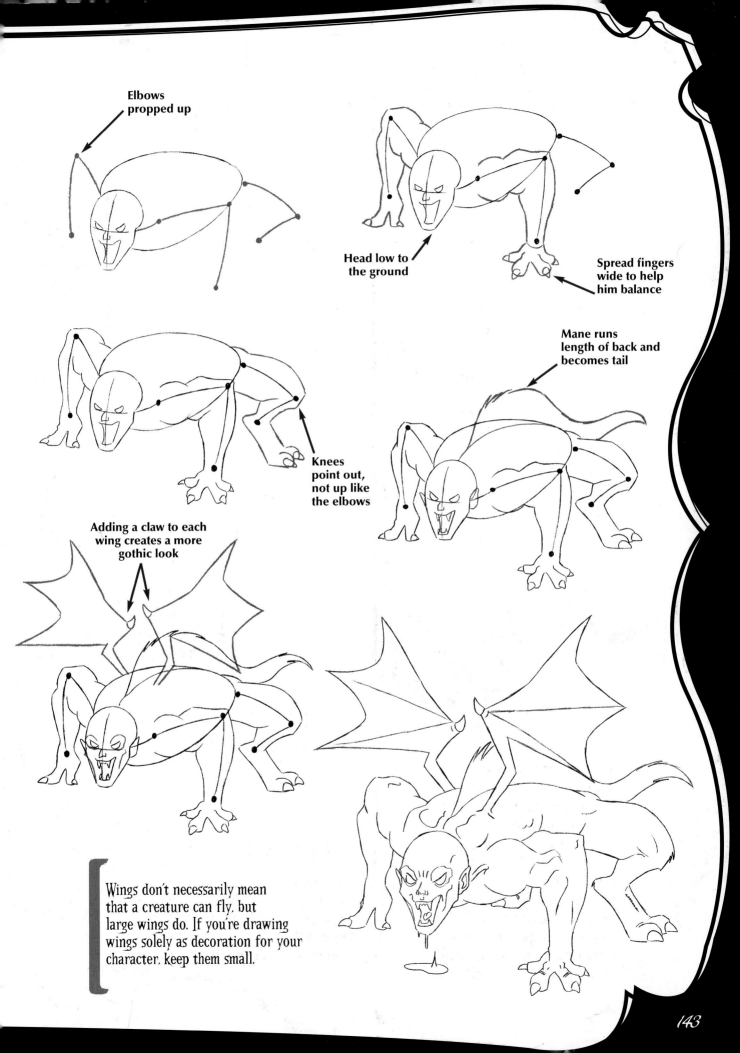

Elbows propped up

Head low to the ground

Spread fingers wide to help him balance

Mane runs length of back and becomes tail

Knees point out, not up like the elbows

Adding a claw to each wing creates a more gothic look

Wings don't necessarily mean that a creature can fly, but large wings do. If you're drawing wings solely as decoration for your character, keep them small.